HOW TO DRAW THOSE
BODACIOUS BAD BABES OF COMICS

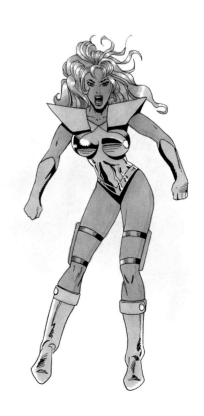

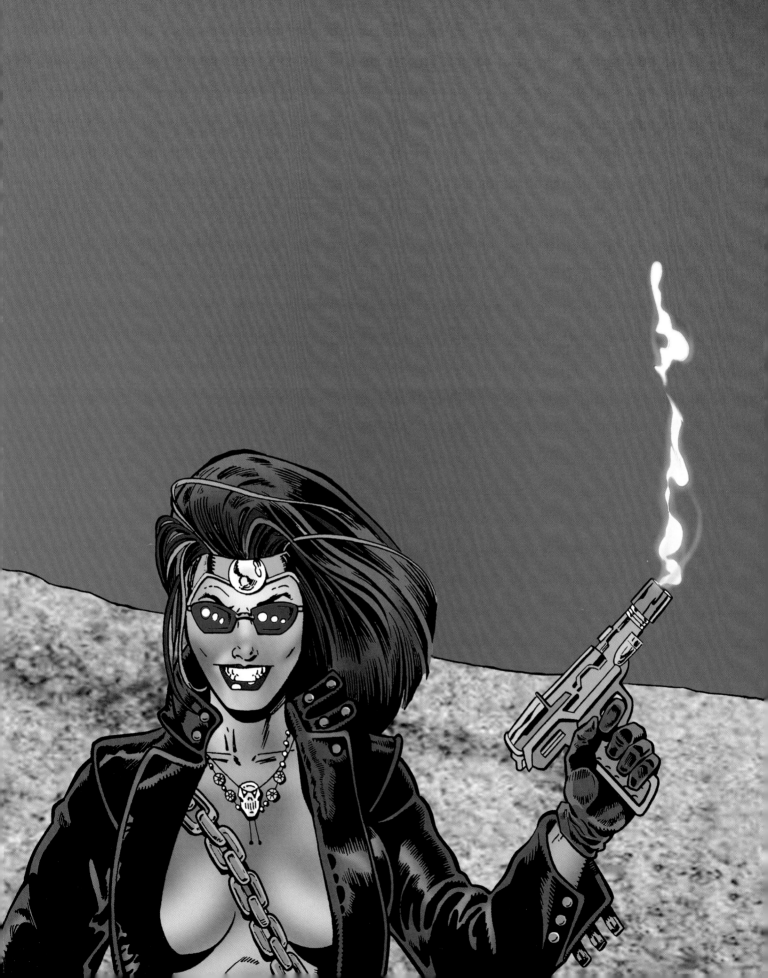

HOW TO DRAW THOSE
BODACIOUS BAD BABES
of COMICS

FRANK McLAUGHLIN
MIKE GOLD
Coloring by Mark Wheatley

RENAISSANCE BOOKS
Los Angeles

Dedicated to Kate, the best of all the "Good Girls."

ACKNOWLEDGMENTS
Sincere gratitude to artist George Sellas for his work on the manga section, Nina Paulson for coloring the marker pages, cartoonist Steve Coughlin for his help, and to Gill Fox for sharing his expertise. Thanks to our publisher, Renaissance Books, especially Ian Culver and James Tran.

RESEARCH ASSISTANTS
Erin Fedeli
Linda Gold
Terry McLaughlin
Noelle Sears

SPECIAL THANKS TO
Pat, Jay, Matt, and all the rest of the gang at Cave Comics in Newtown, Connecticut, for all their help, as well as to the guys and gals at Insight Studio in Baltimore, Maryland.

EXTRA SPECIAL THANKS TO
Writer/artist and color guy extraordinaire Mark Wheatley. You're the best, Mark!

Library of Congress Catalog Card Number: 99-067286

10 9 8 7 6 5 4 3 2 1

Design by James Tran

Published by Renaissance Books
Distributed by St. Martin's Press
Manufactured in the United States of America
First Edition

CONTENTS

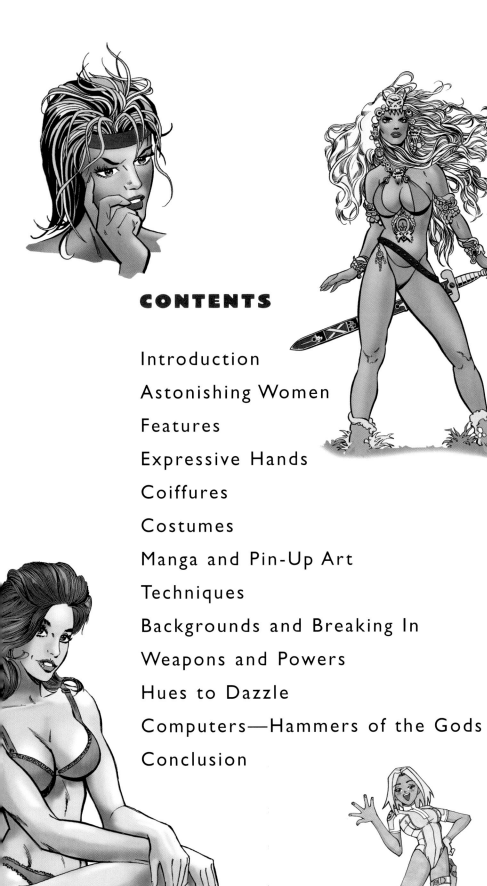

Introduction 7

Astonishing Women 11

Features 43

Expressive Hands 51

Coiffures 61

Costumes 69

Manga and Pin-Up Art 77

Techniques 87

Backgrounds and Breaking In 101

Weapons and Powers 111

Hues to Dazzle 121

Computers—Hammers of the Gods 131

Conclusion 141

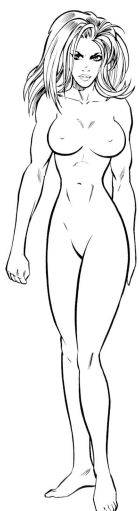

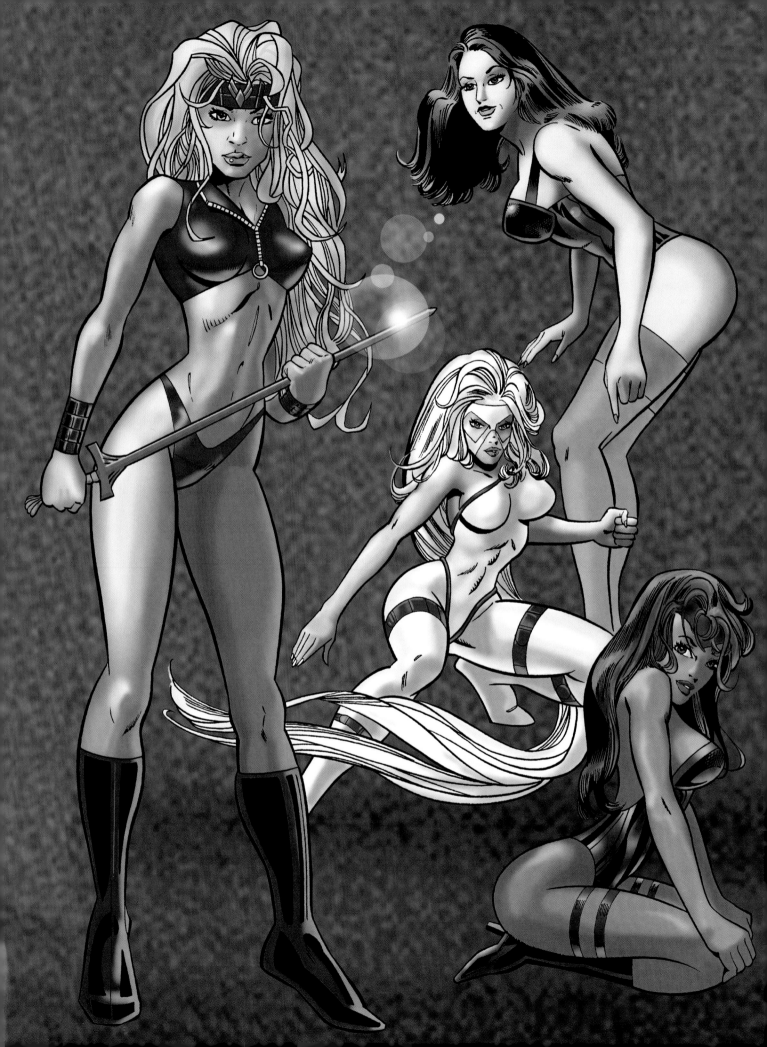

INTRODUCTION

So, you want to draw Bodacious Babes? For the record, "bodacious" means unmistakable, remarkable, and/or noteworthy. It does not necessarily mean big-breasted. Most people—real or fictitious—are remarkable or noteworthy in their own way, and it is the artist's job to figure out how to translate those qualities into a visual representation.

So . . . why would you want to learn how to draw Bodacious Babes? If self-amusement isn't an issue, we'll assume you have some sort of career path in mind. You've probably already contemplated earning a living in one of the following fields:

Advertising—Whereas it's still pretty big, the world of advertising illustration is not as big as it once was—photography crowded out the illustrators years ago.

Magazine Illustration—Again, there isn't as much work here as there used to be. A few "cutting-edge" magazines use illustrations; of course, they tend to work in a cutting-edge style. News magazines

use a small amount of graphics, but they are usually in a newspaper, editorial-cartoon style. It's rare to see a bodacious illustration in *Newsweek*–babe or otherwise.

Comic Books—The comics business needs new blood and new ideas, and sooner or later even the long-established outfits will figure that out. That's where you come in.

Animation—A simple glance through any recent issue of *TV Guide* will reveal that there has been huge growth in the animation field. Over the past few years, the animated versions of comics like *Batman* and others have been thriving. Even original shows like *The Simpsons* have proven that animation can endure in prime time. Today, virtually every motion-picture studio (not just Disney) is producing two or three a year, not counting the direct-to-video market.

The Internet—There are tens of thousands of wondrously illustrated Web sites that supply users with more information and entertainment than the print media ever did at speeds that are getting faster and faster. What does that mean to you? On the Internet, everybody and their aunt can be a publisher. The cost of entry is far lower than it is in hard-copy publishing.

Video Games—When you look at a video game you see all kinds of characters, devices, and backgrounds. Well, somebody has to design them, and that's rarely the technicians' job.

Remember, artistic styles might differ, techniques might evolve, but the concepts remain the same, so be sure to cover the bases—there are a number of books out there that reprint some of the best pulp illustrations, while others reprint the great magazine illustrators.

If the only comics you've looked at are very recent, you've missed out on a lot. Don't ignore the classic newspaper-strip artists, either. Soak it all up! Find and study favorites, but make sure they remain influences and don't comprise your whole style—everyone has something unique to offer.

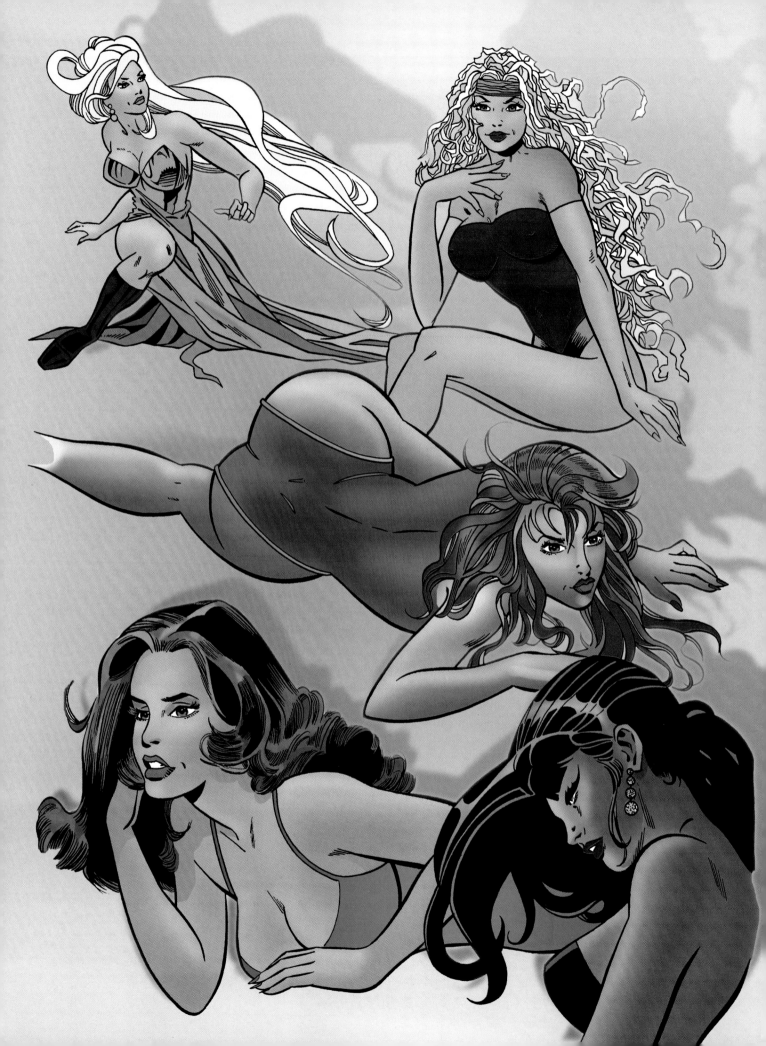

ASTONISHING WOMEN

Good Girls" are those wholesome women who seem forever trapped in a black-and-white sitcom. They're well-groomed and they pay a lot of attention to detail. "Bad Girls" are extremely disquieting. They might start well-groomed, but then they go wild. Their hair remains perfect, but "perfectly" disheveled. Their eye makeup goes past perfect and right into dangerous. These are the women you are likely to meet right before the second commercial on *The X-Files*.

THE GOOD GIRL

All proportions are based upon the head size. Draw a big head on a normal figure—you'll see how your figure seems small. Now draw a small head on that same normal figure—you'll see how your figure seems big.

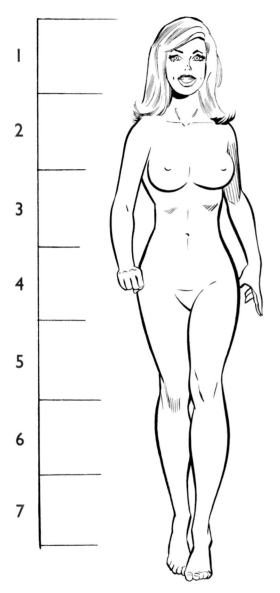

Good Girls tend to be normal in height; that is, about 7½ heads high. Each head measurement should land on or near each of the following landmarks: 1) obviously, the chin, 2) nipples, 3) navel, 4) groin, 5) just above the knee, 6) mid-calf, 7) just above the ankles, and 7½) the sole of the foot.

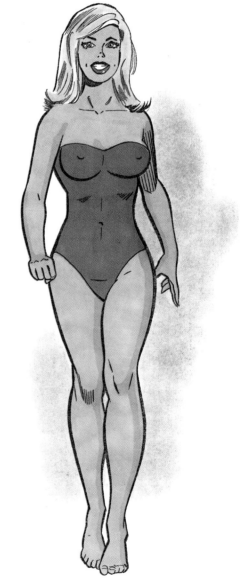

You can adjust each of these measurements slightly if you wish, but that's about as fancy as it gets. Pretty simple, huh? After you draw the figure often enough, you'll see just how easy it is to hit these "landmarks" every time without actually measuring them.

THE BAD GIRL

When sketching Bad Girls these days it is quite fashionable to draw skinny women with large breasts and supernaturally long legs. Like all gimmicks, though, it is extremely easy to let this get out-of-hand, and you've got to learn the line between what is natural but exaggerated, and what is too bizarre to believe.

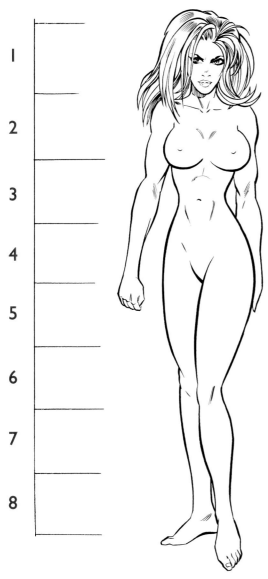

These measurements are just a guideline for you to start from. For example, if you look at some fashion illustrations, you may see some figures as tall as 14 heads high! Superhero women haven't gotten that tall . . . yet.

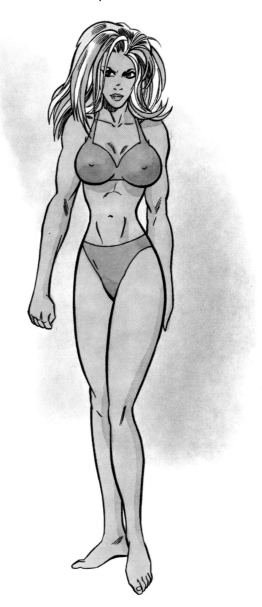

The Bad Girl is only slightly different in proportion. You might want to make her 9 heads high, with the added length in the legs. The "landmarks" are about the same until you reach the groin, where the legs begin to stretch longer. This Bad Girl is a mere 8 heads high—one unit longer in the legs.

POSING THE GOOD GIRL

Good Girls have the ability to create viewer interest merely by standing there. Drawing the hips and shoulders in opposing directions creates a natural look. Below, the tilt of the breasts, the slope of the shoulder, and the pointing toe show that this girl is breaking the plane.

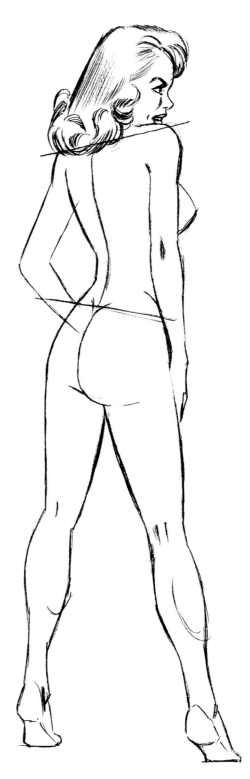

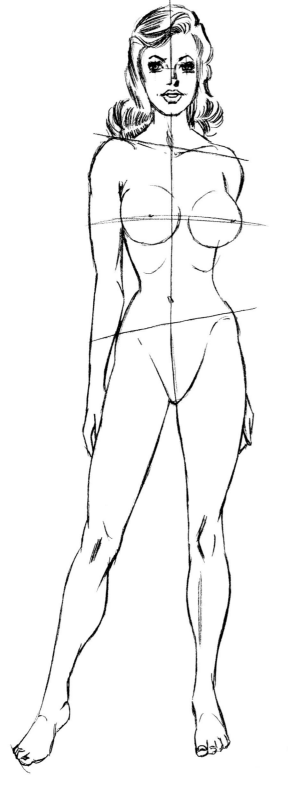

This girl's shoulders aren't parallel to her hips. Try drawing the same figure with hips and shoulders parallel and you'll see that no matter what you do, that stiff, awkward look just won't go away.

14

Hand-color her and she's ready to walk off the page.

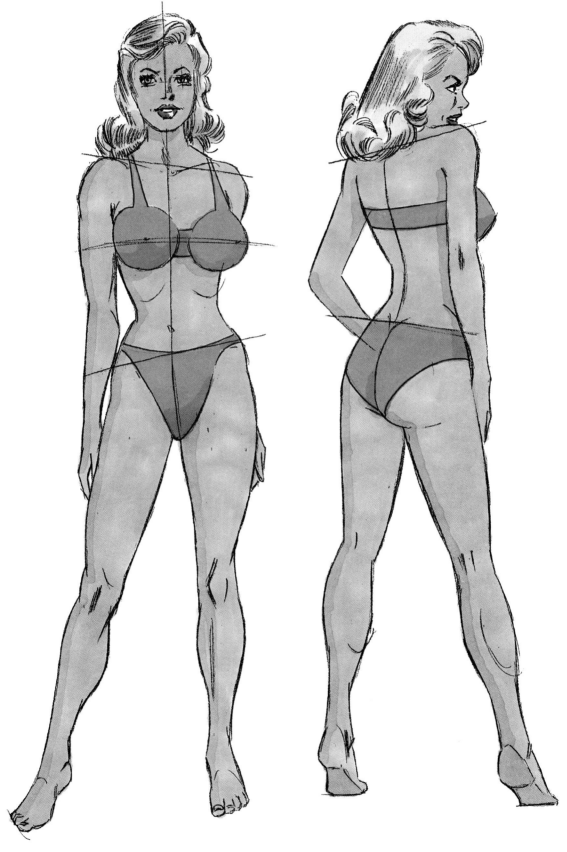

POSING THE BAD GIRL

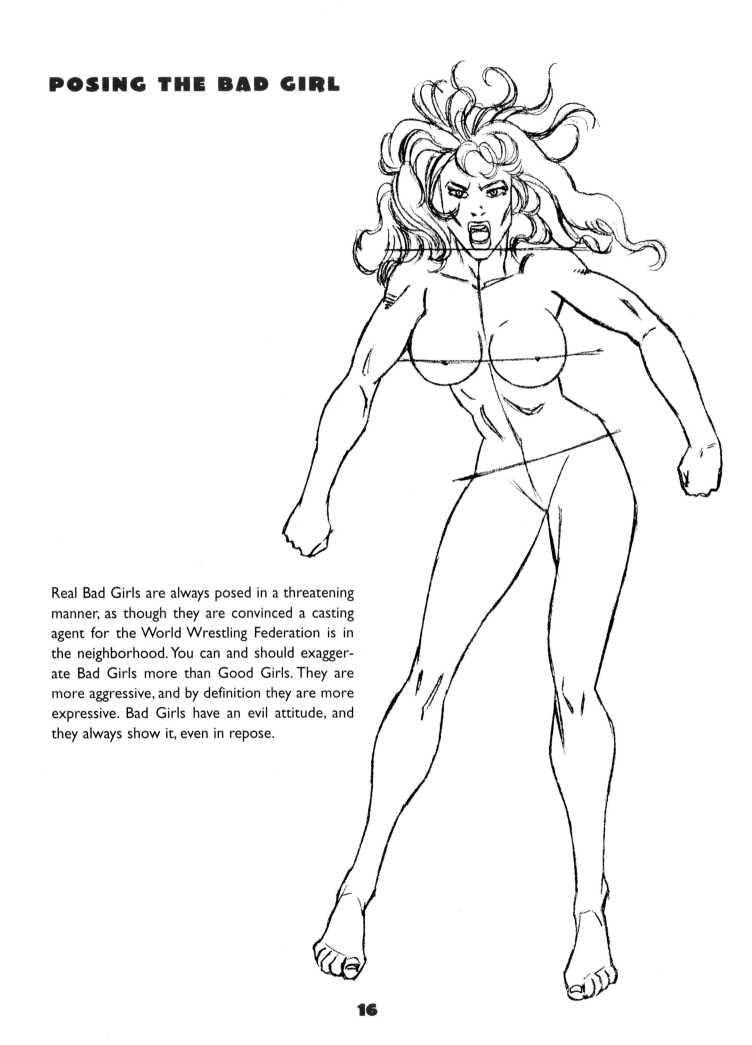

Real Bad Girls are always posed in a threatening manner, as though they are convinced a casting agent for the World Wrestling Federation is in the neighborhood. You can and should exaggerate Bad Girls more than Good Girls. They are more aggressive, and by definition they are more expressive. Bad Girls have an evil attitude, and they always show it, even in repose.

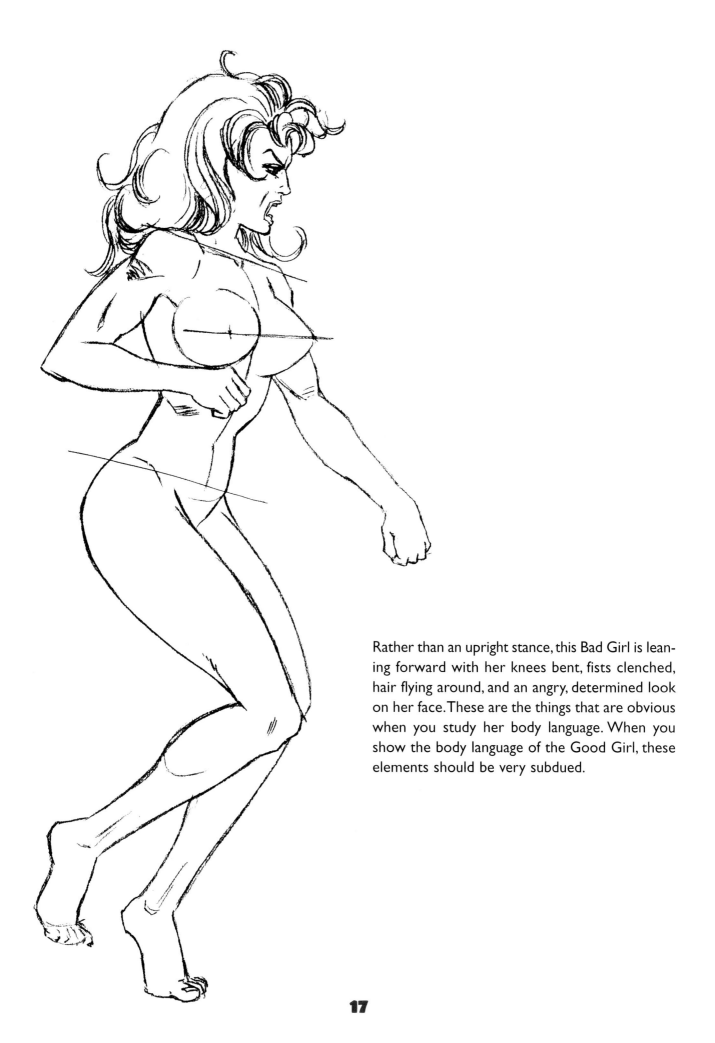

Rather than an upright stance, this Bad Girl is leaning forward with her knees bent, fists clenched, hair flying around, and an angry, determined look on her face. These are the things that are obvious when you study her body language. When you show the body language of the Good Girl, these elements should be very subdued.

SIMPLE POSES

Let's go back a step and begin to draw, starting with a typical Good Girl pose. Begin by establishing the line for the spine.

Because the spine is never straight, let's give it a slight curve. The shoulders and hips are tilted in opposite directions and we try to keep her head positioned more or less over her supporting foot (figure 1). At this point in our drawing we should have nothing more than a few scribbled, loose lines. Don't be concerned that she doesn't yet look like that vivacious, alluring creature you have in mind. We'll get to the finished product soon enough.

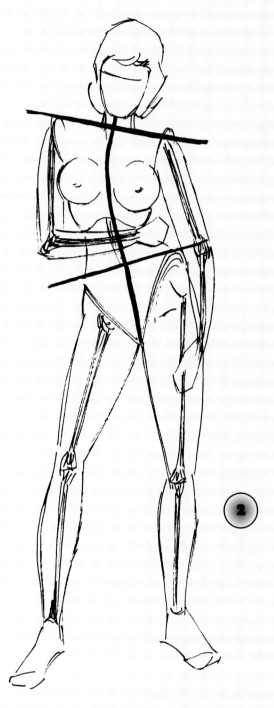

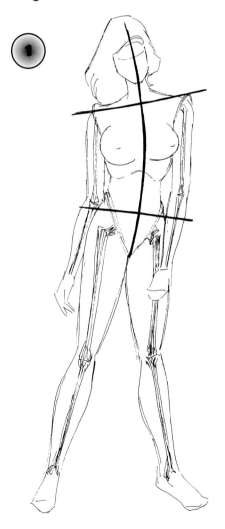

Experiment with the way you add shapes like circles, rectangles, and triangles to your stick figure. Most drawings are constructed by determining what shapes are appropriate to use, and then putting them together. Make sure these shapes are the correct size (figure 2).

COMPLICATED POSES

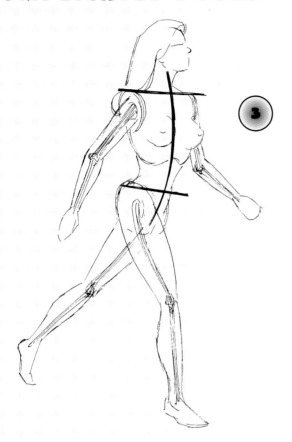

Let's try drawing our Good Girl while she is moving (figure 3). Begin as before, by establishing the curve of the spine and lightly placing the shapes properly. When people walk, their arms and legs move in opposition to each other—that is, when the right leg is in front, so is the left arm. Notice how the sticks for arms and legs are drawn as major bones.

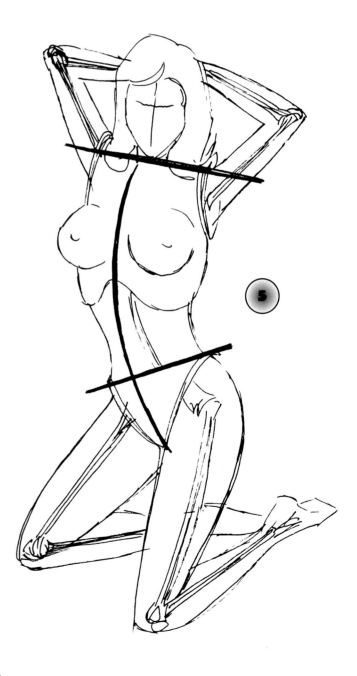

Seated or kneeling poses (figures 4 and 5) are constructed in the same manner. Roughly indicate the shape of her hair, and then put these drawings aside. We all desperately want to finish our drawings at this point, but try to resist that urge and let's move on.

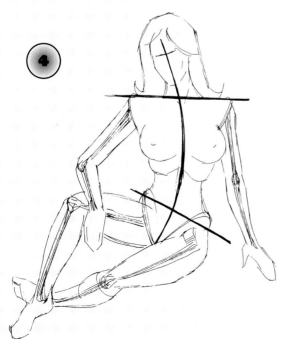

Now we can experiment with poses that are a bit more complicated. Flying, holding a weapon, or just plain agitated, these girls are ready for action. You've done well if you've created a feeling of attitude, action, or intent without putting in any detail. There's no substitute for time spent drawing, however.

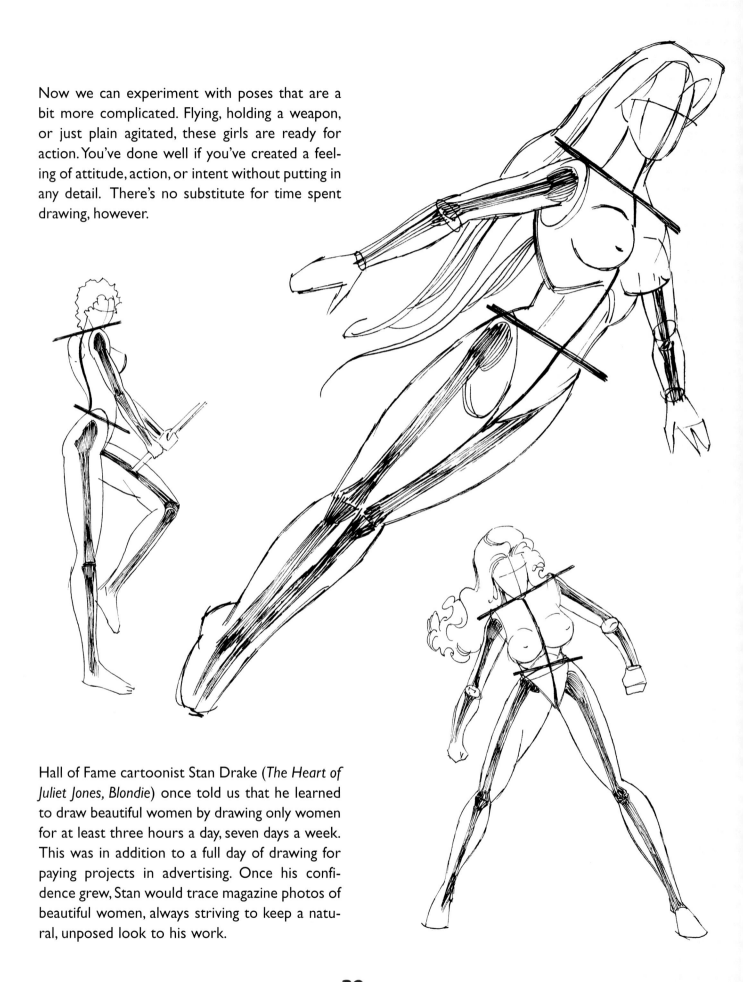

Hall of Fame cartoonist Stan Drake (*The Heart of Juliet Jones, Blondie*) once told us that he learned to draw beautiful women by drawing only women for at least three hours a day, seven days a week. This was in addition to a full day of drawing for paying projects in advertising. Once his confidence grew, Stan would trace magazine photos of beautiful women, always striving to keep a natural, unposed look to his work.

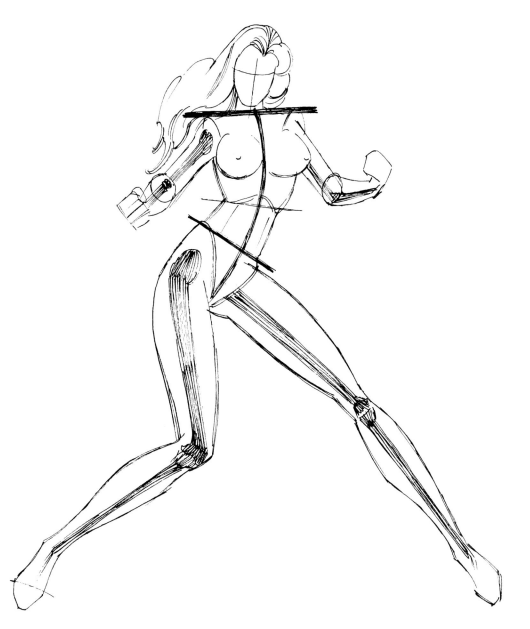

Let's get a little more adventuresome. Here are a couple of long-legged women who are very flexible. Try some poses of your own creation and be as fearless as you can. No artist ever began without undergoing a certain amount of self-doubt or discouragement. You're no different, so just keep plugging away, no matter what. After a while you'll see your work gradually improve, and along with it, so will your confidence. You'll need a strong ego to continue as a successful artist.

MORE GOOD GIRL POSES

Sometimes it's easier to draw the far-out **Bad Girls** than it is the sweet women-next-door. These next few pages contain typical poses of **Good Girls** in action and repose. Note how the axis lines of these women are never parallel. Start as before, and when you get to the point where you want to give your drawings a more finished look, go right ahead. The hand-colored girl on the opposite page would be perfect to introduce to your parents.

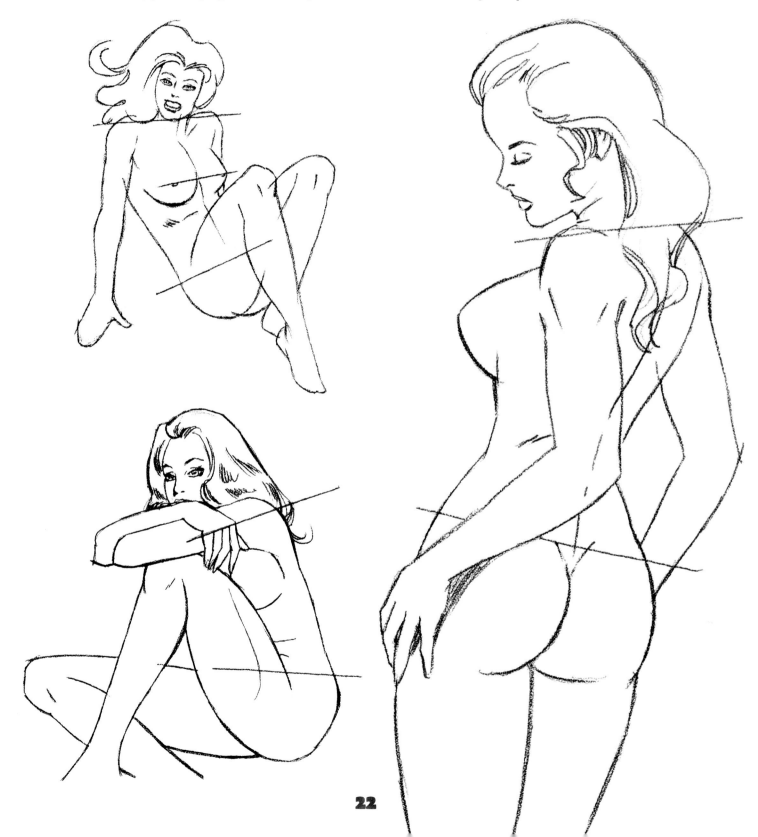

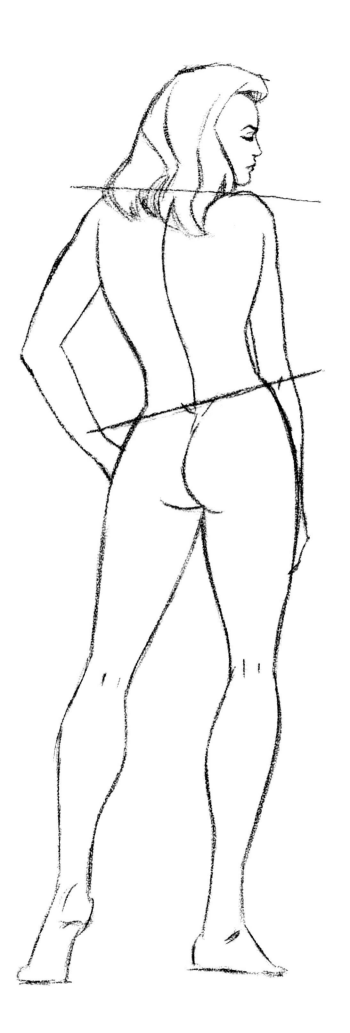
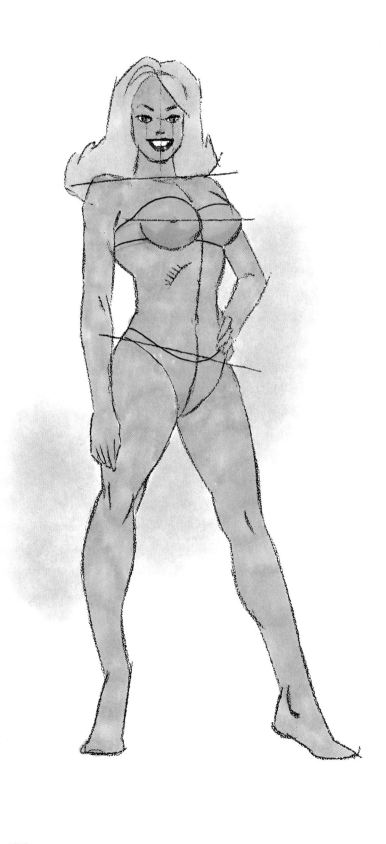

Draw your preliminary construction lines very lightly. Keep a kneaded eraser in your hand so those lines can easily be erased as you begin to "tighten up" your work. Indicate hairstyle with just shapes and maybe a few light lines. Here the axis lines are more or less parallel, the dynamics of the poses are in the curved spine on the left, and the angles of arm and leg on the right.

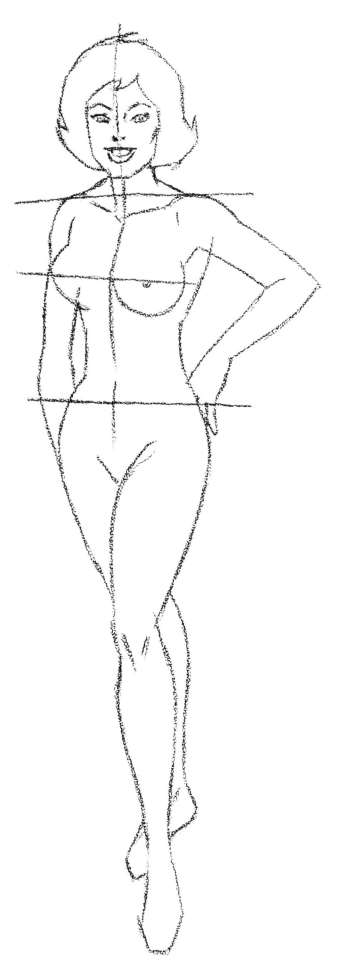

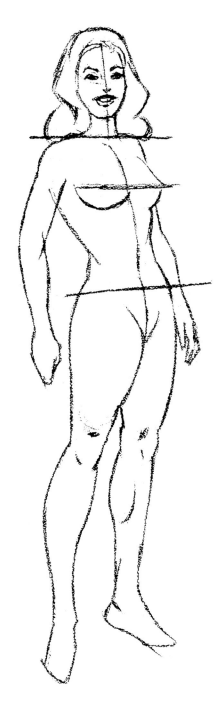

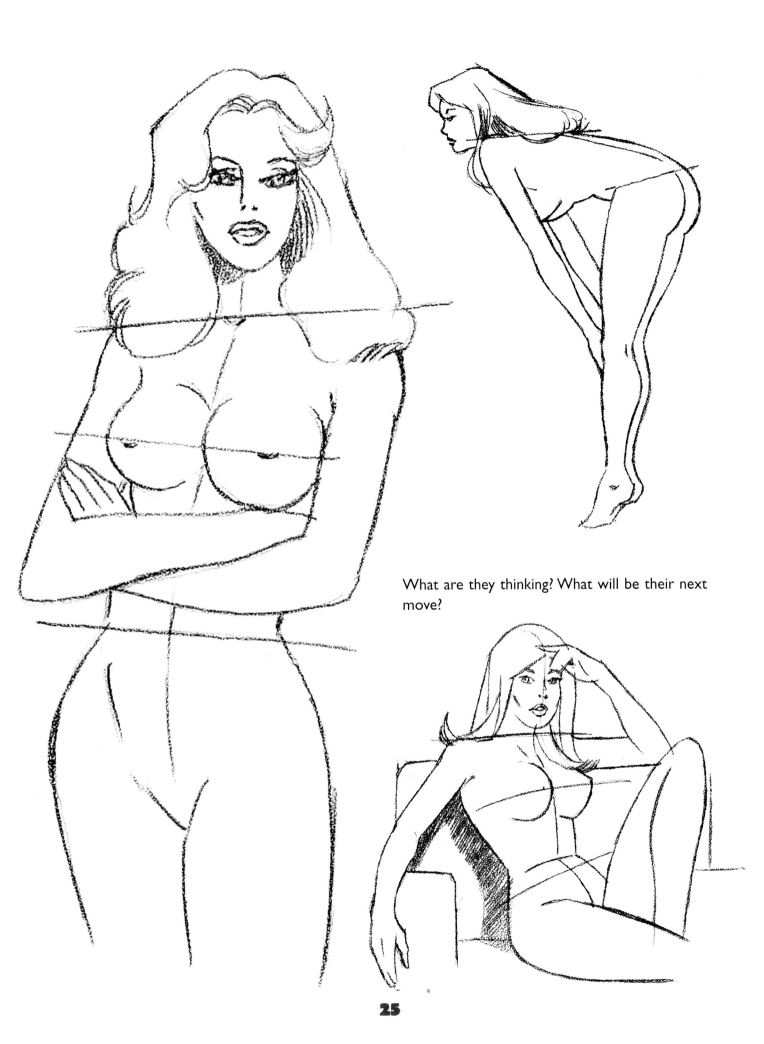

What are they thinking? What will be their next move?

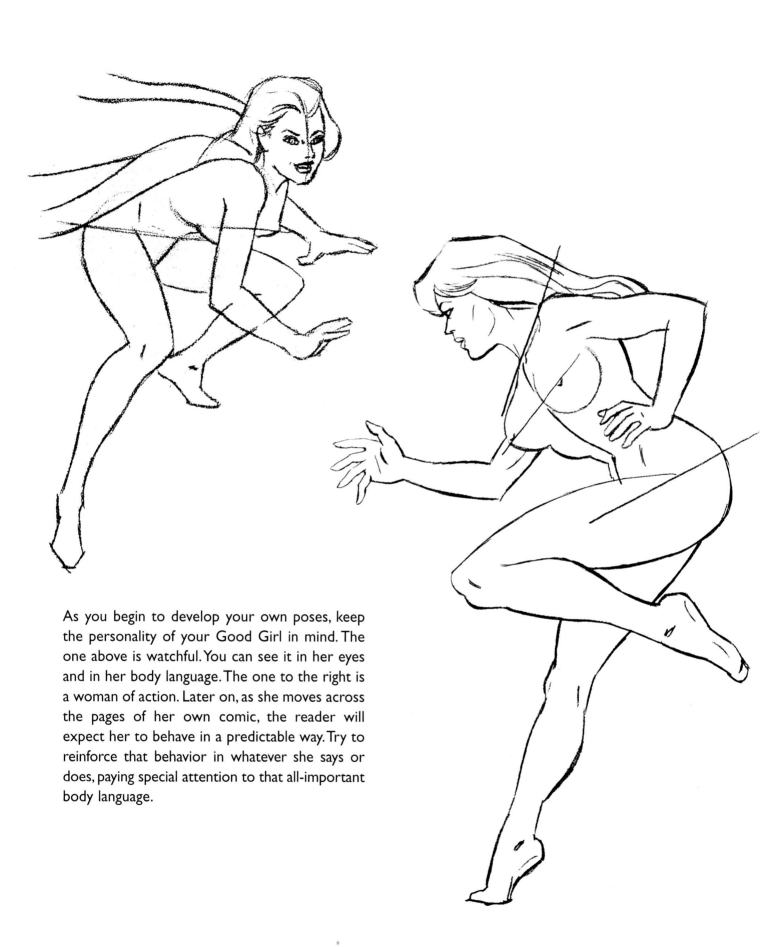

As you begin to develop your own poses, keep the personality of your Good Girl in mind. The one above is watchful. You can see it in her eyes and in her body language. The one to the right is a woman of action. Later on, as she moves across the pages of her own comic, the reader will expect her to behave in a predictable way. Try to reinforce that behavior in whatever she says or does, paying special attention to that all-important body language.

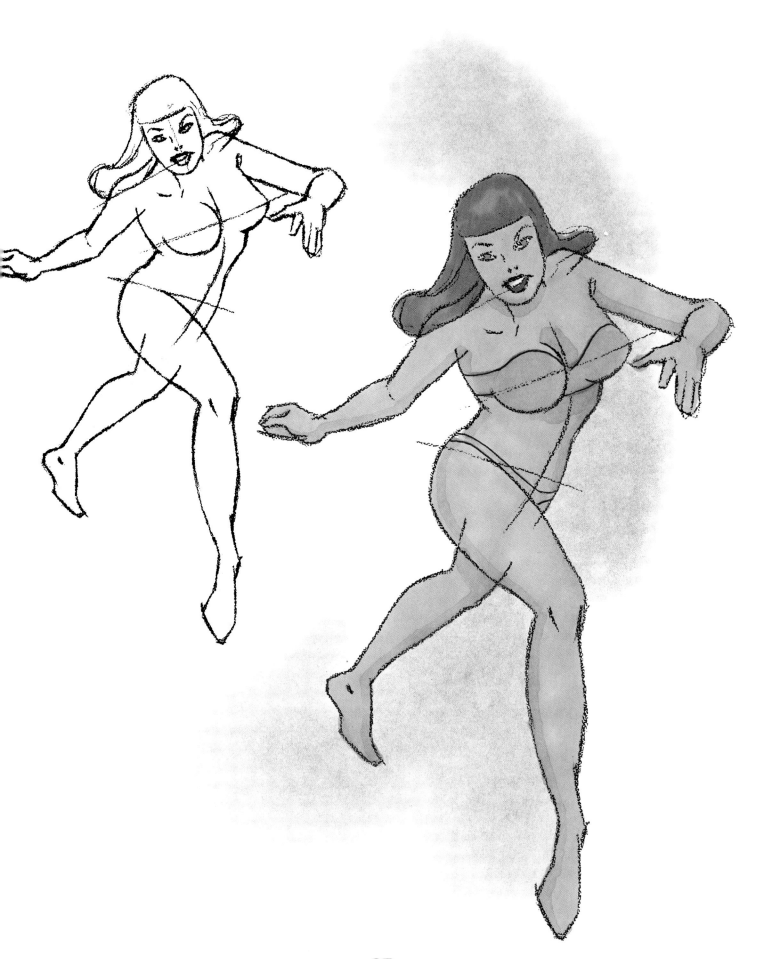

MORE BAD GIRL POSES

Bad Girls appear threatening, but the trick is to make them appear both threatening and alluring at the same time. They, too, move with pride, but theirs is of a more predatory nature. Bad Girls are usually in attack mode, or at least appear to be on the verge of lunging. They're out to get you, and that bit of body language must be readily apparent to the reader. The girl on the left has a very curved spine, but her neck curves back the opposite direction, giving her tension. Notice how much is indicated by her eyes and her restless fingers.

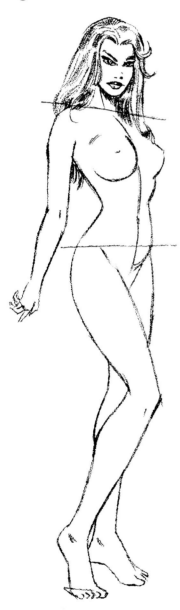 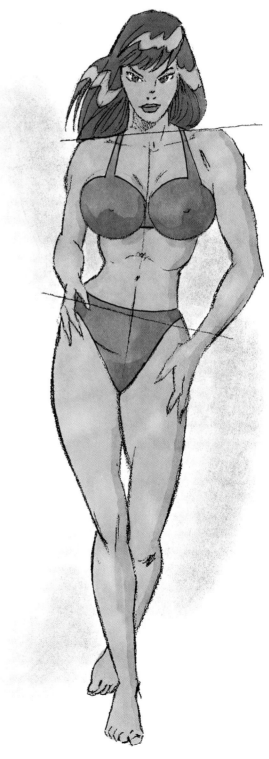

As you begin to construct her figure, keep referring back to the Bad Girl's measurements on page 13. Although it is only a guide, it will serve as a reminder to keep her legs longer than the Good Girl's.

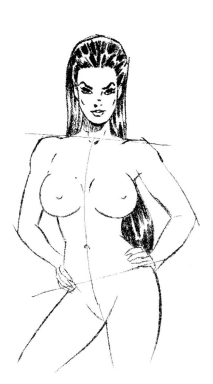

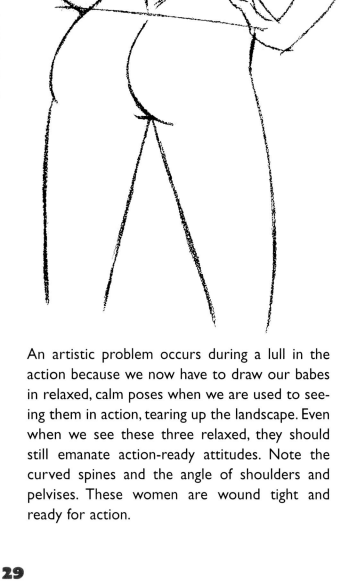

Comic stories have what we call "hills and valleys." The hills are the action-packed scenes and the valleys are the quiet interludes between them. These quiet valleys are very important to the telling of the story. Without them, the dynamics would suffer greatly.

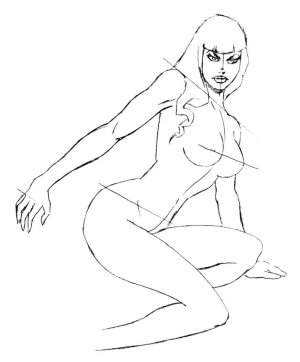

An artistic problem occurs during a lull in the action because we now have to draw our babes in relaxed, calm poses when we are used to seeing them in action, tearing up the landscape. Even when we see these three relaxed, they should still emanate action-ready attitudes. Note the curved spines and the angle of shoulders and pelvises. These women are wound tight and ready for action.

FORESHORTENING

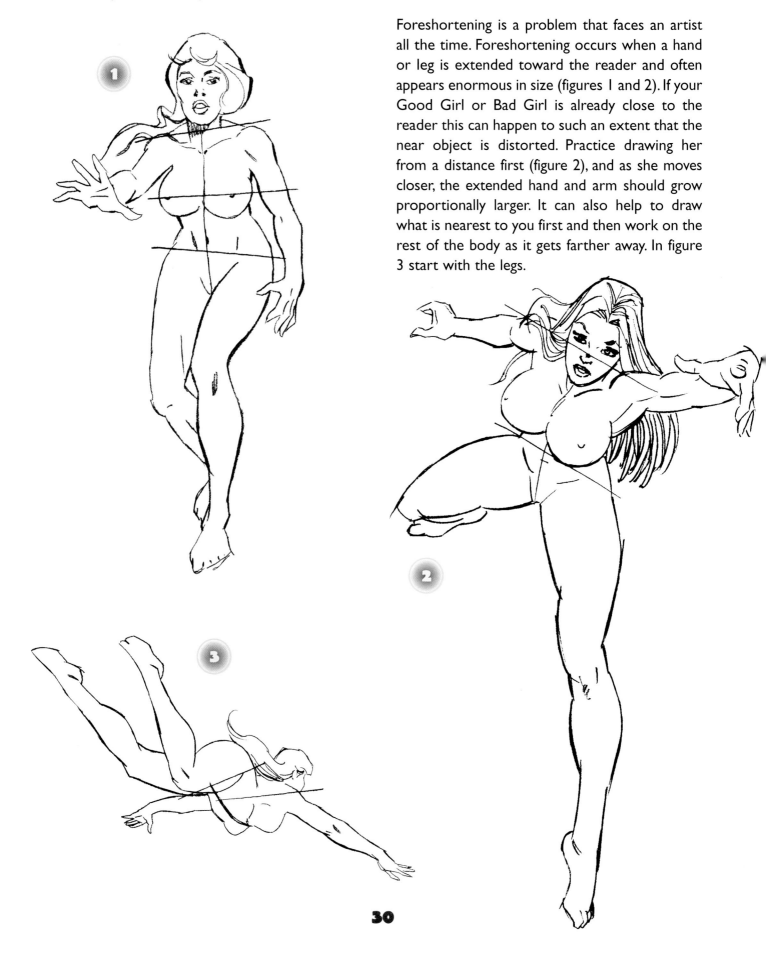

Foreshortening is a problem that faces an artist all the time. Foreshortening occurs when a hand or leg is extended toward the reader and often appears enormous in size (figures 1 and 2). If your Good Girl or Bad Girl is already close to the reader this can happen to such an extent that the near object is distorted. Practice drawing her from a distance first (figure 2), and as she moves closer, the extended hand and arm should grow proportionally larger. It can also help to draw what is nearest to you first and then work on the rest of the body as it gets farther away. In figure 3 start with the legs.

BABES IN ACTION

In filling your sketchbook, the same things apply when drawing the Bad Girl that did with the Good Girl. Start with light construction lines and build on them step by step.

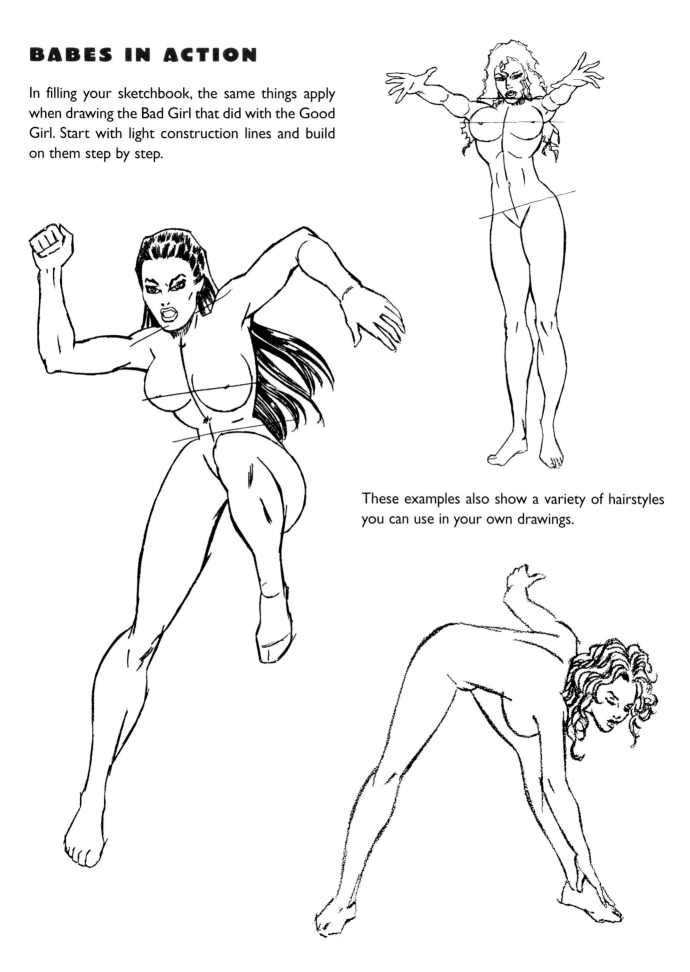

These examples also show a variety of hairstyles you can use in your own drawings.

Don't be afraid to overexaggerate her poses when beginning your drawings. You can back off on a pose that seems to go way over the edge and bring it back to reality as you progress.

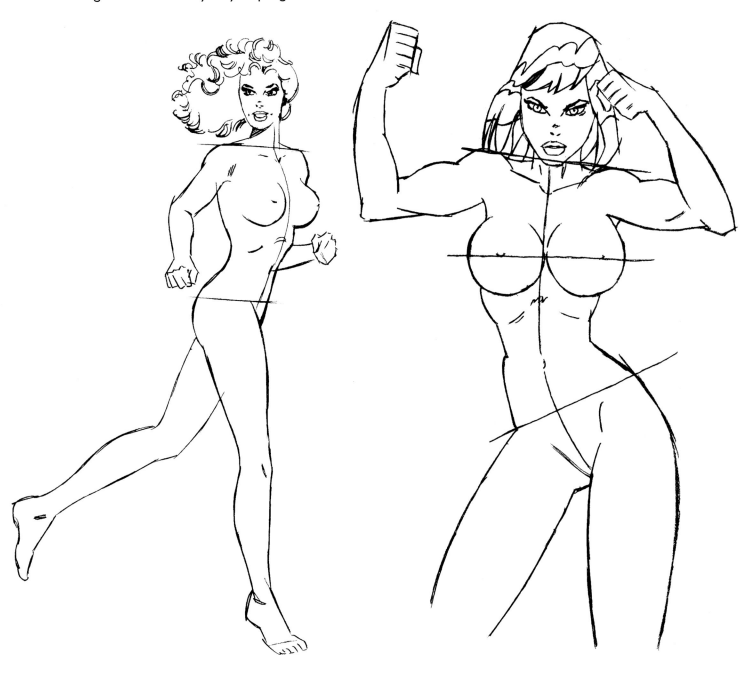

At one time or another, we've all done a drawing that began with a dull pose. No matter what we do to it, that drawing never becomes something exciting to look at. Be adventuresome. Be bold. Take her to the edge.

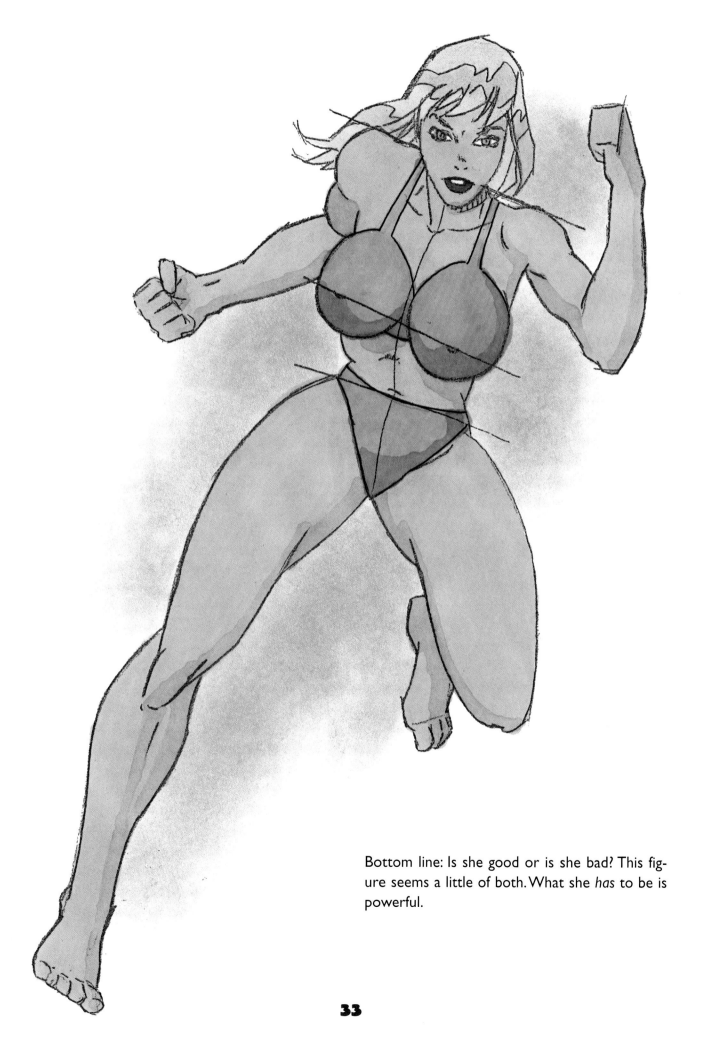

Bottom line: Is she good or is she bad? This figure seems a little of both. What she *has* to be is powerful.

SKETCHING

So far we've focused on long shots and full-figure sketches. But comics are full of close-ups as well, and they require more attention to details.

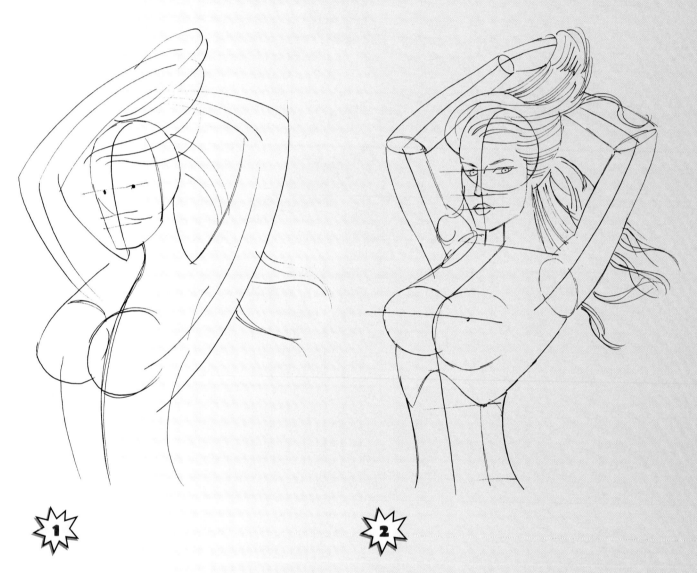

Don't be afraid to start all your drawings with a scribble. That's right, a plain old doodled, messy scribble. Quite often these scribbles set the tone by creating rhythm to your drawing. Figure 1 is the result of simple scribbles, but the lines you see are a few of the many that we chose to continue with.

In figure 2, we can begin to construct the important shapes and position facial features, rib cage, and arms. Those little ellipses in the arms help to make them feel round. Begin to indicate the swirling hair.

INKING

This is a good time to try our hand at inking. For now, you might want to use a fine-line marker like a Pilot Razor-point. Later on, you might progress to brush inking with India ink. Most inkers prefer watercolor sable brushes like a Windsor-Newton, Series Seven, No. 2. There are many permanent India inks to choose from. Among them are Black Magic and Pelikan.

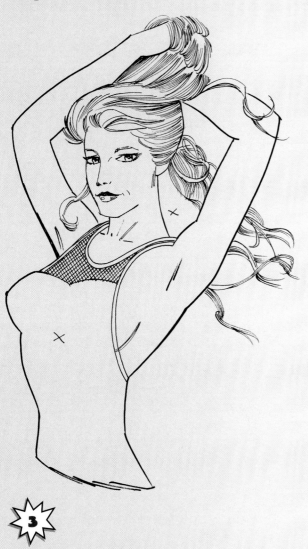

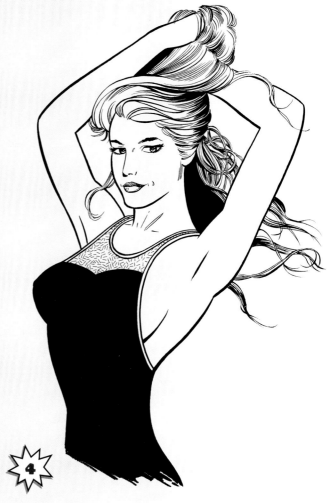

Place an "X" in the areas you intend to fill in solid black (figure 3). Save your black areas until you finish all your linework. Then come back in with an old, worn-down brush for filling in. Save your new, pointed brush for linework.

Try to create form in the hair. Notice how the hair gets darker at the back of her head as it turns away from the reader (figure 4). Be careful when you use crosshatching (screen-doorlike) effects. These tiny little spaces tend to plug up when the drawing is reduced in size. For that reason I changed the pattern in her top from figures 3 to 4. There are a lot of technical concerns to keep in mind such as the final reproduction size or the method of printing. . . . Cheap inks and shoddy presses are going to give your work a rougher, cheaper appearance and will greatly increase the possibility of plugging up.

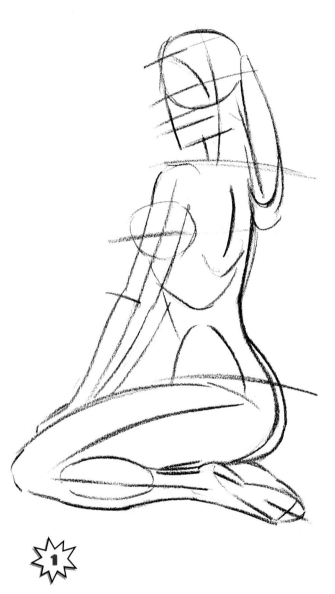

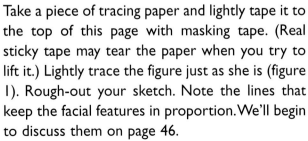

Take a piece of tracing paper and lightly tape it to the top of this page with masking tape. (Real sticky tape may tear the paper when you try to lift it.) Lightly trace the figure just as she is (figure 1). Rough-out your sketch. Note the lines that keep the facial features in proportion. We'll begin to discuss them on page 46.

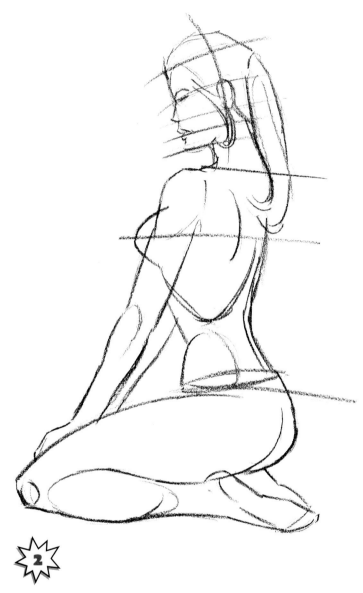

Repeat the process for figure 2. This time, economize. Now she is beginning to look like a real babe instead of a mannequin. Still, keep the pencil lines light.

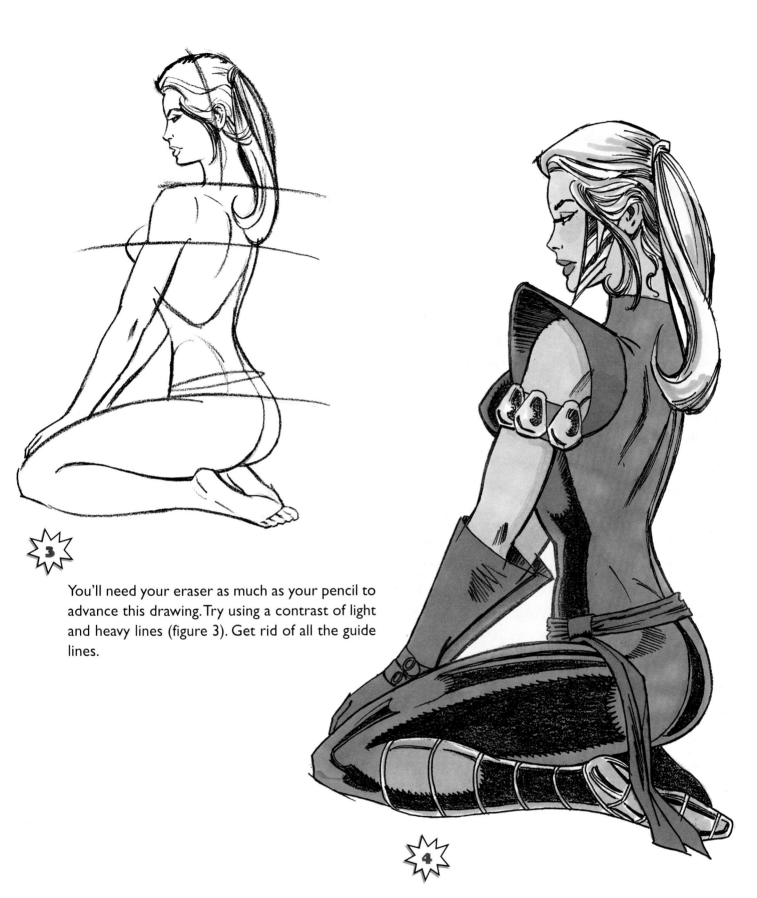

3

You'll need your eraser as much as your pencil to advance this drawing. Try using a contrast of light and heavy lines (figure 3). Get rid of all the guide lines.

4

When the nude figure is perfect, then, and only then, you can costume her (figure 4).

TRACING THE BAD GIRL

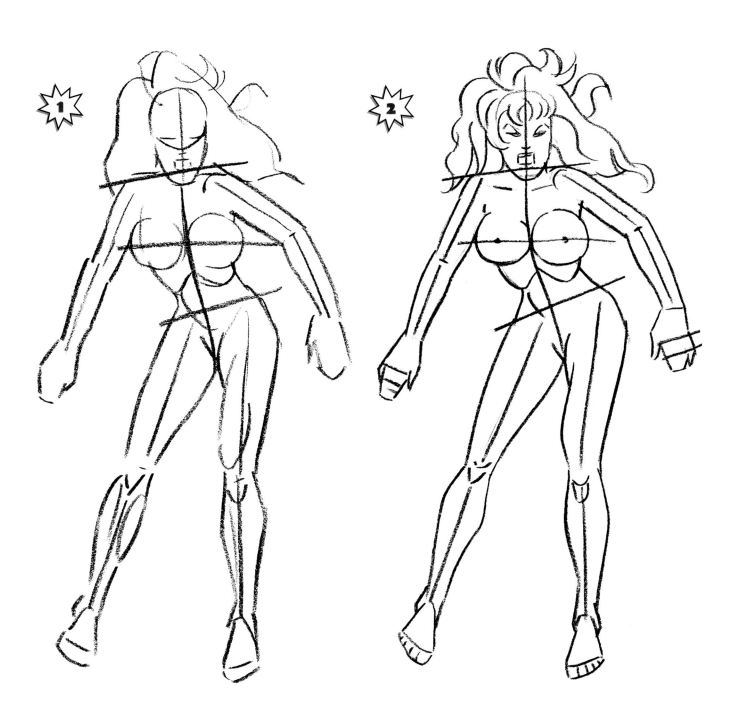

Let's shift gears and try the same process with a not-so-sedate Bad Girl. Already we know what her attitude is, just from this very rough drawing (figure 1). Tape down your tracing paper and dive right in.

In figure 2 erase anything extra. Develop the body language attitude by filling in the facial features. Keep in mind we are just locating and "blocking in" body parts with simple shapes.

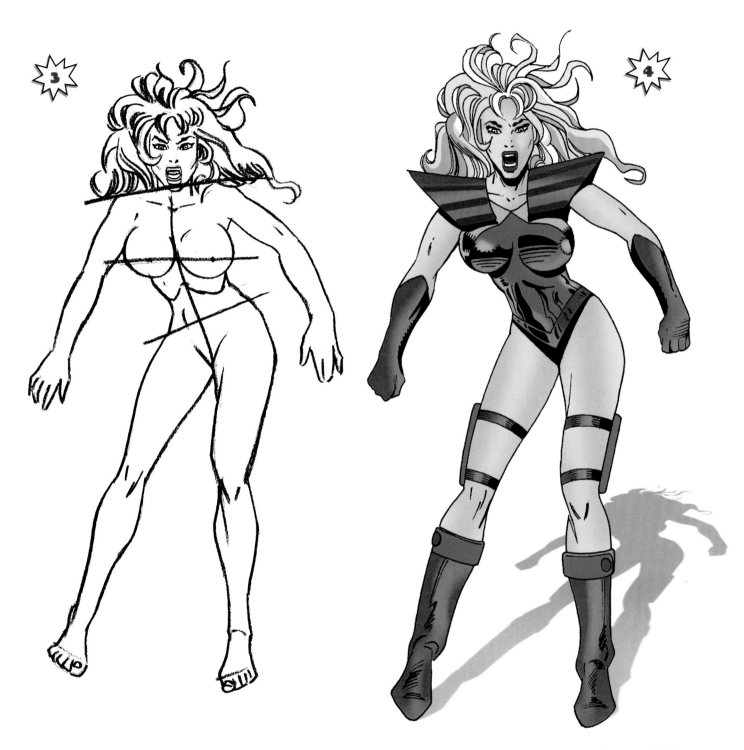

Tighten up your drawing in figure 3, but still be careful not to bear down with your pencil. Keep her hair wild-looking and make sure she keeps the angry look on her face.

Have some fun with her costume (figure 4). Try adding your own designs here. Spandex material causes highlights. Copy and color.

THE BAD GIRL, FREEHAND

Now, see if you can draw a Bad Girl freehand, but use the same methods. Take your time. Rome wasn't built in a day, and neither was *this* nasty royal babe.

Keep your pencil lines light (figure 1). It takes enough time to do the actual drawing, so you don't want to spend more time erasing and cleaning up than you have to. Besides, later on you'll be adding her costume and detailing her hair. We'll talk about the grid lines that lay out her facial features starting on page 46.

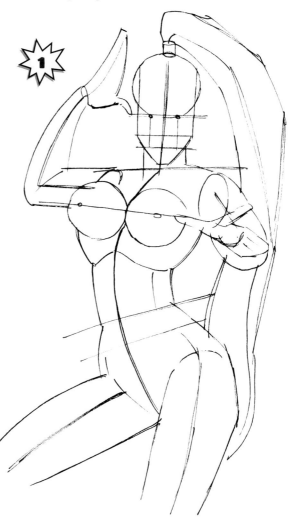

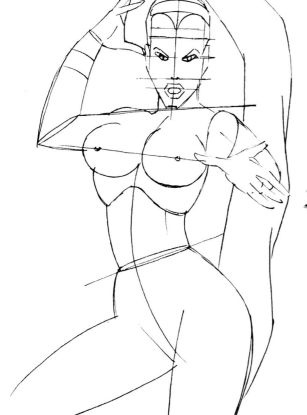

Hairstyle signifies action, and hairstyle must match facial emotions (figure 2). In turn, hair and facial emotions create an attitude that match her body language. Note that the drawing makes the same statement in several ways: the pose of her body, the depiction of her hands, and the expression on her face all show defiance and readiness.

Work the whole drawing at the same time (figure 3). It's tempting to start at the top and work your way down, putting in the details as you go. You should fight off this temptation—you'll get better results by approaching your work as a whole unit and not simply as a collection of details. Don't be afraid to do a number of rough drawings until you are completely satisfied with your work.

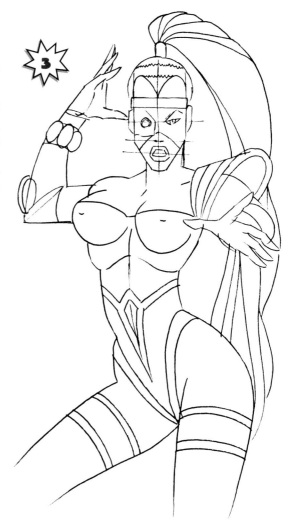

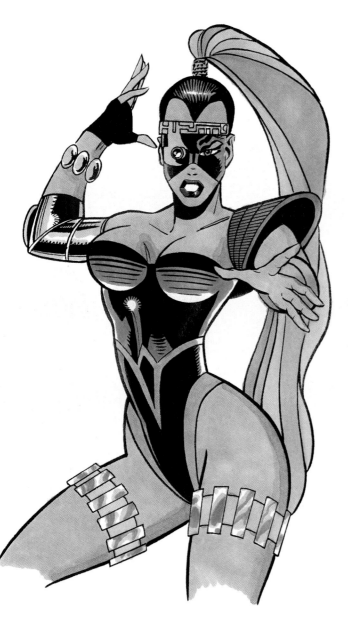

If you design your own costume, don't let it get too bulky or clumsy-looking. It would be a real shame to hide this babe underneath a bunch of stuff (figure 4). Experiment with your own color schemes while you're at it.

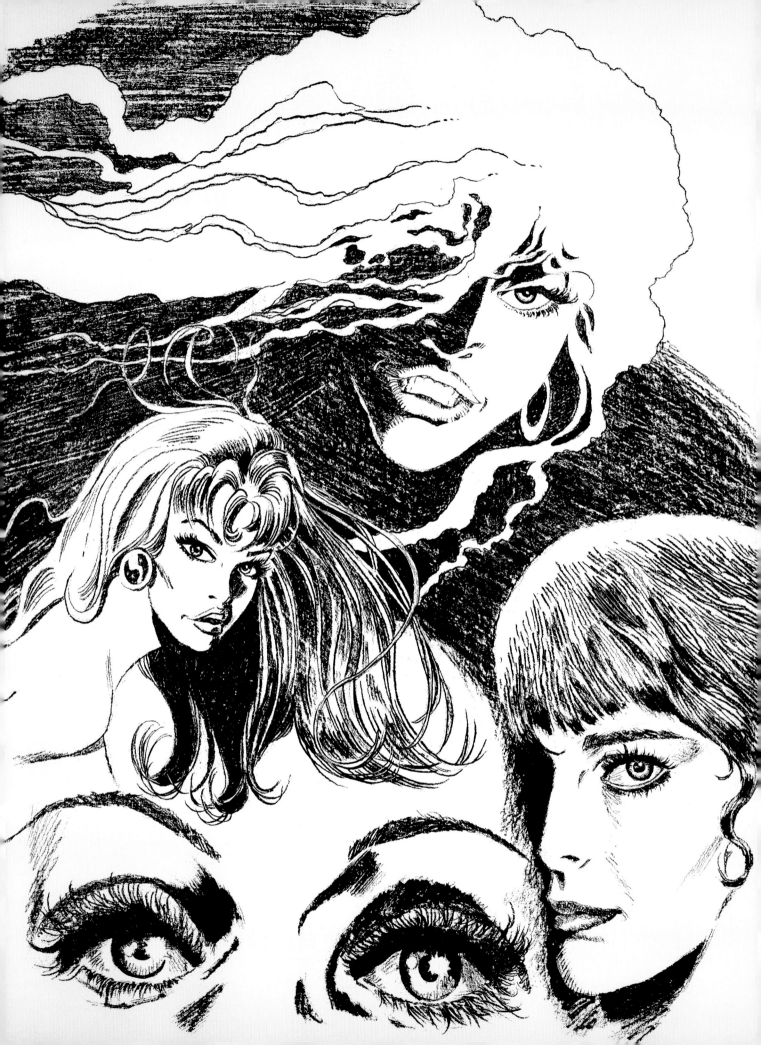

FEATURES

As we've begun to see, we distinguish individuals not only by size, coloring, hairstyle, and clothing, but also by their facial features. The subtle differences in the shape of the eyes and the posture of the head not only distinguishes one character from another, but also give hints to the reader as to her personality and state of mind.

Let's explore those differences in facial expression, as shown by the Good Girls of comics and our own Bodacious Bad Babes.

THE GOOD GIRL'S FACE

Figure 1 is a straight, head-on shot of your everyday, do-gooder superheroine type. After deciding the basic shape of her face, place a line at the top of her head, and another at her chin. While you're at it, let's draw a center line right down the middle. The rest is just as easy. Halfway between the top and bottom lines is where her eyes are located. Halfway between her eyes and chin should be another line. This is where her mouth is located. See? We told you it was easy.

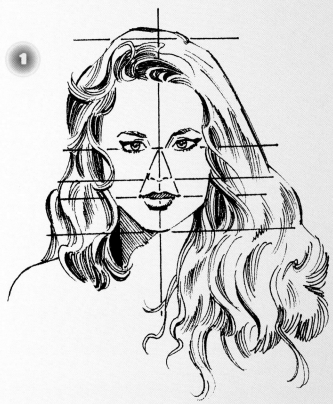

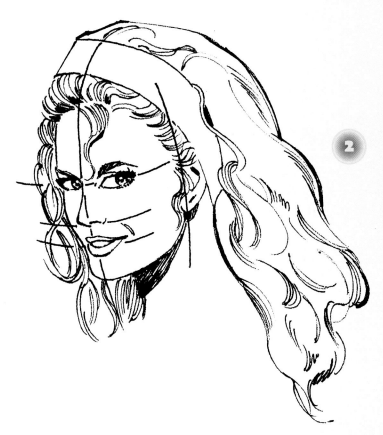

As we turn her head into a three-quarter view (figure 2), her features will curve a bit. When we get to the side view (figure 3), we see some undeveloped real estate—a perfect place to construct an ear.

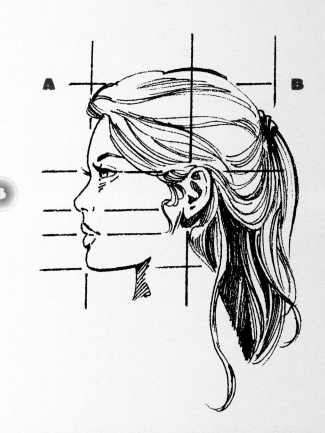

On this side view (figure 3), draw another top-to-bottom line that bisects the head line AB. The front of the ear butts up against this line—some artists tend to place the ear too close to the front of the face, so be sure to keep it on and behind that center line where it belongs. From top to bottom, the ear runs from the half-line where the eyes rest, to the line where the bottom of the nose is to be found.

THE BAD GIRL'S FACE

Let's get more specific about locating parts of the face.

It's the subtle differences that set the bad girl apart (figure 1). For one thing, her brow may be a bit wider than that of her Good Gal counterpart. After putting in the center line, place others at the top of her head (feel free to chop off a bit of hair), and the point of her chin. Halfway between, you might expect to find the spot to place her nose. Drop that line just a bit to make her nose a little longer. Now add the guide line for her mouth.

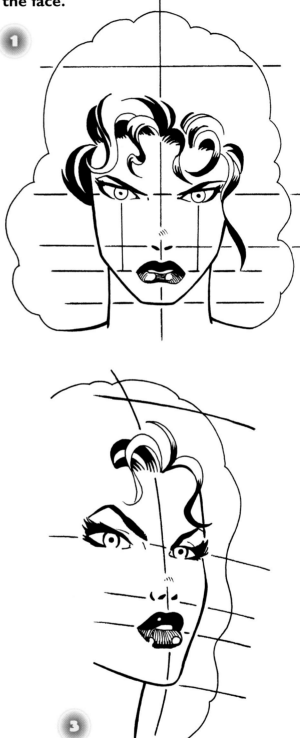

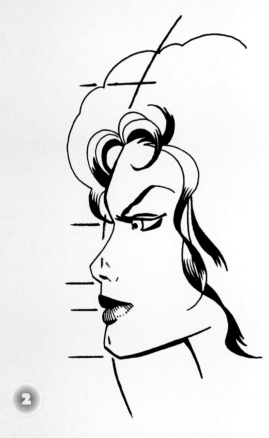

The side view, or profile, is also a bit different (figure 2). The center line that comes down between her eyes is now a slightly exaggerated curve.

Figure 3 shows the three-quarter view. Our villainess is looking at someone off to your right. Any of these three angles make up the vast majority of the views you will use in a comic story.

THE GOOD GIRL'S FACIAL FEATURES

Now that you know where everything goes, it's time to pay attention to how it looks. Remember, you will also accentuate the features and define your character's personality through the use of makeup.

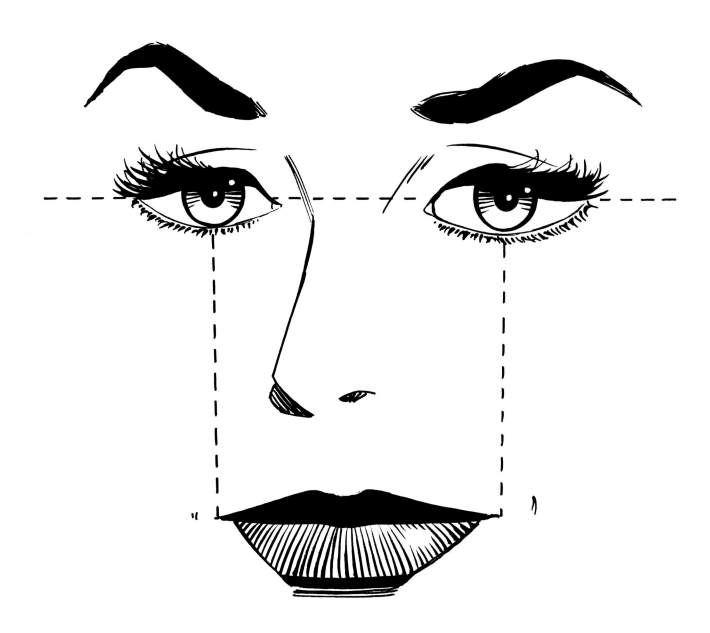

Basically the Good Girl has warmer, squarer softer features—larger, more expressive eyes, and a rounder, fuller mouth.

THE BAD GIRL'S FACIAL FEATURES

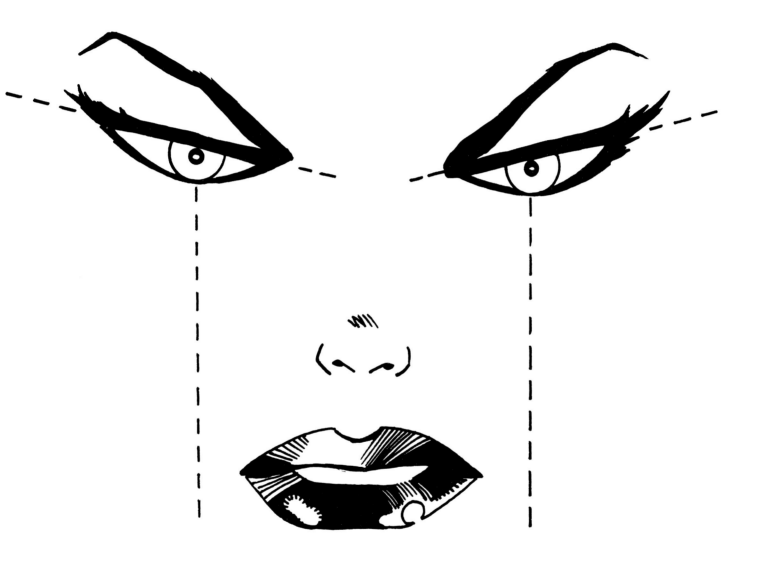

Bad Girls have somewhat sharper, more angled, and glaring features. The eyes and brows slant down sharply, creating the illusion of higher cheekbones and the feeling of impending anger.

Similarly, the Bad Girl's lips appear smaller because they are turned downward and pursed in a threatening manner. The corners of the lips do not quite extend to the middle of the eyeball, as they do in the Good Girl.

EYES, ETC.

Oftentimes, visual storytelling starts with the establishment of clichés: When showing surprise, the Good Girl has more white around the eye-balls (figure 1), larger highlights, and arched eye-brows.

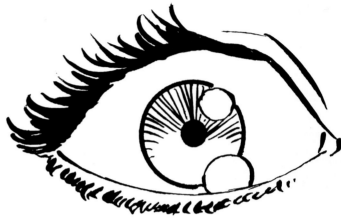

The Bad Girl is less likely to show surprise, instead entering most situations with a determined and threatening ambience. You can have more fun with her eyes and features by using outrageous make-up, tattoos, and the like (figure 2).

Some artists have trouble showing facial features from a low angle, or worm's-eye view. Draw your guide lines so that they follow the curve of her skull (figure 3).

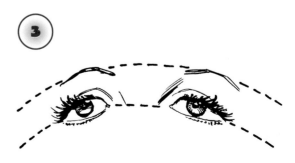

The mouth, lips, and teeth can present drawing problems as well. Because her teeth curve in an arc, so do her lips. We want to indicate bright, white teeth, so keep the front line-free and only hint at lines as the rows of teeth turn away from the reader. Even then, those lines indicate shadows cast from the adjacent teeth. The Good Girl's lips are left blank for later coloring (figure 4), and a small white spot is left on the lower lip to indicate a moist highlight. Baddie's lips are heavily rendered to help give her that hard-edged look (figure 5). The mouth in figure 6 might be mistaken for the front end of an old Buick. That's because the artist chose to outline every tooth.

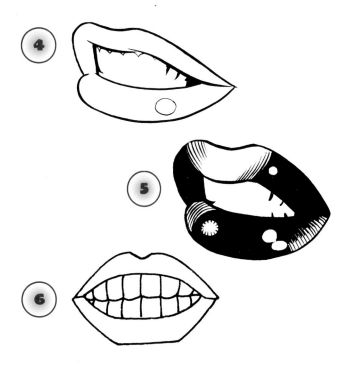

At first glance ears seem so complex to draw that we often end up with something resembling an old catcher's mitt. Study these three drawings (figure 6) and you'll see just how simple they are. On Bad Girls, longer, tapered ears suggest hostility; pointed ears suggest devilspawn.

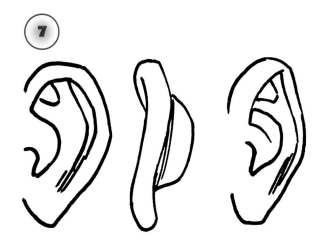

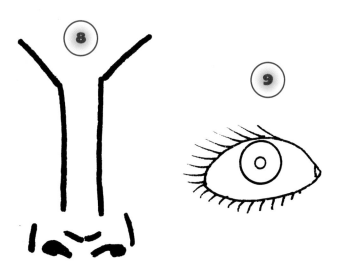

When your model faces you directly, you can often leave out both sides of the bridge of the nose. If her nose is not of the "pug" variety, try using a single line on just one side. Figure 8 shows you how the nose can look flat if you line both sides of it. Try treating eyelashes in clumps instead of individual lines (as done in figure 9). Keep in mind that, unless you do some modeling in the eye itself, she might wind up with a blank stare.

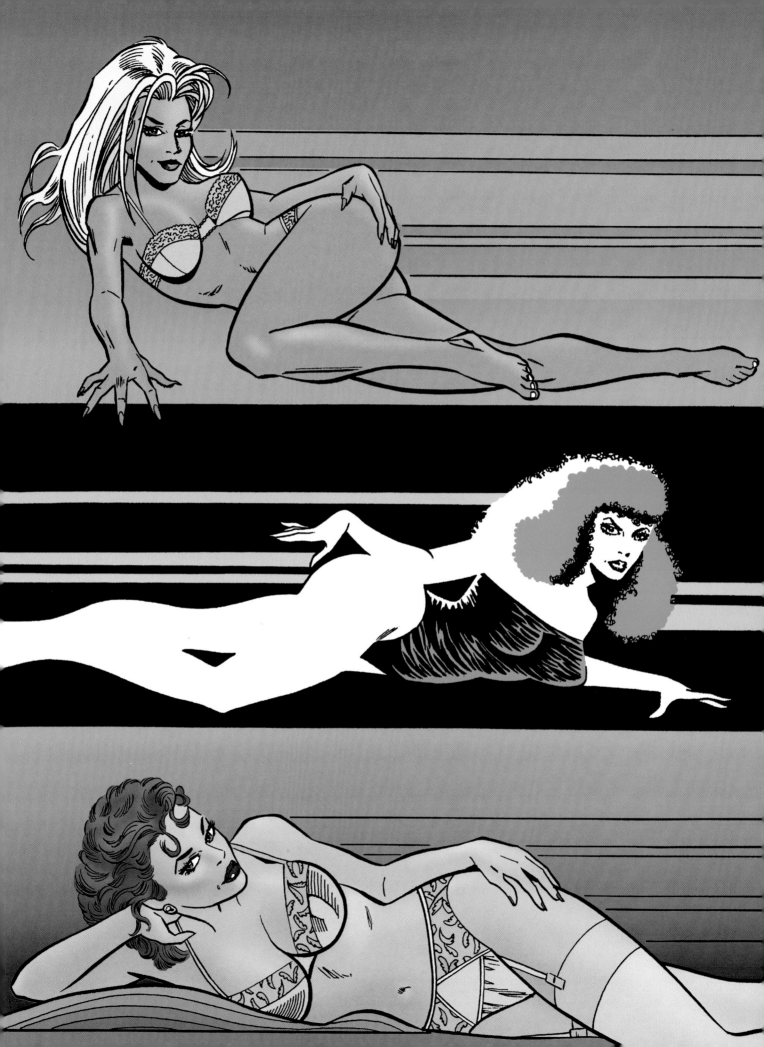

EXPRESSIVE HANDS

The eyes are the most expressive part of the face, but you've got to get up close to see them. It's the hands that will beckon you from across the room, that will punctuate every verbal sentence, that will stop you in your tracks. And nobody ever got a slap in the face from a woman's eyes.

Ultimately, the posture of the hands will override all other elements. You can take the most evil face and give her the sharpest fingernails, but if you put those hands in a pious position you will communicate consideration and sympathy. The position of the hands will communicate what's going on in your character's mind.

BASIC HAND ANATOMY

Moving away from the face, we reluctantly come to one of the most difficult parts of the body to draw: the hands. Everything we say about the hands also applies to the feet, but we can hide those puppies with shoes or boots.

You can learn how to draw and move the hand by breaking the parts up into boxes and cylinders. It's easier to see where the joints go and how they work (figure 1).

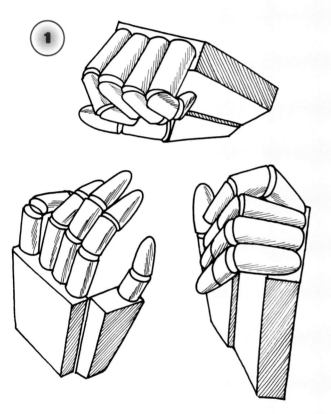

Remember, we are walking around in the greatest frame of reference an artist could hope for. Simply put—use your own hand as a model (figure 2).

Treat the thumb section as a hinge that folds back and forth in opposition to the rest of the hand. Now practice drawing hands holding objects from many different angles (figures 3 and 4).

SIMPLE HAND POSES

When you draw women's hands in repose, note how the relaxed wrist comes into play. Try to carry a sketchbook with you whenever possible, and record the wrists and hands you observe.

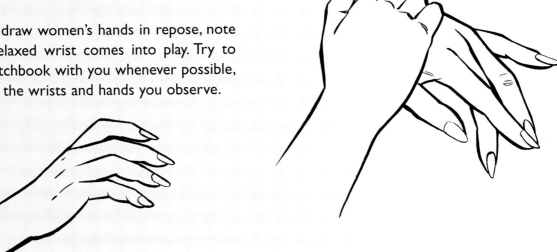

Some art schools even require their students to carry a sketchbook at all times . . . or suffer severe penalties. Sketch other people wherever you happen to be—on a bus, on a break, at school or work, anywhere at all! After a while your sketches will take on the natural look you've been striving for. Draw, draw, draw!

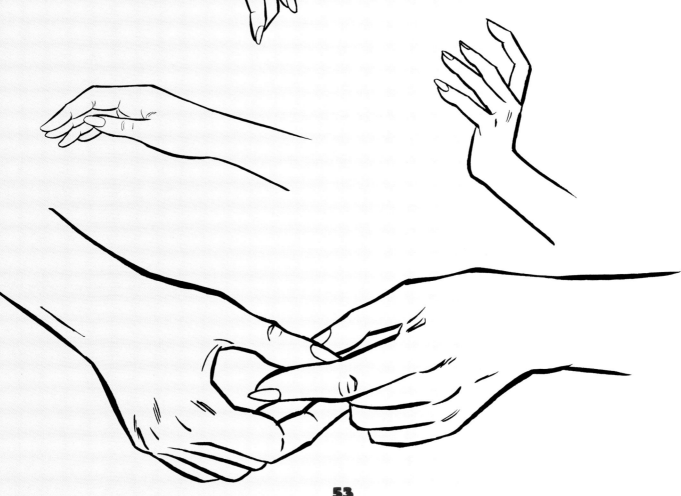

DRAWING THE HANDS AT WORK

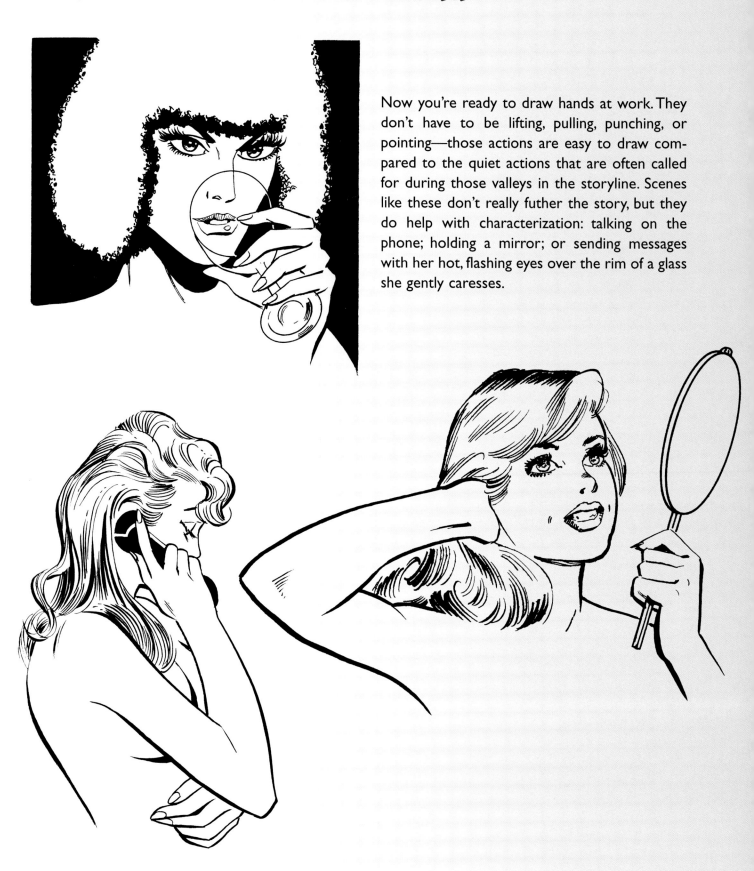

Now you're ready to draw hands at work. They don't have to be lifting, pulling, punching, or pointing—those actions are easy to draw compared to the quiet actions that are often called for during those valleys in the storyline. Scenes like these don't really futher the story, but they do help with characterization: talking on the phone; holding a mirror; or sending messages with her hot, flashing eyes over the rim of a glass she gently caresses.

Now comes a real test of your storytelling ability—combining the action of her hands with that of her face. If you get the expression of the hands and face right, everything else doesn't really matter that much.

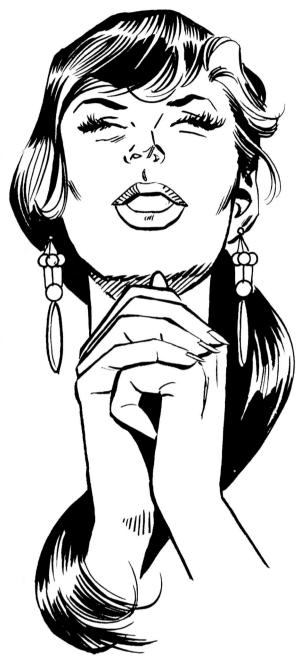

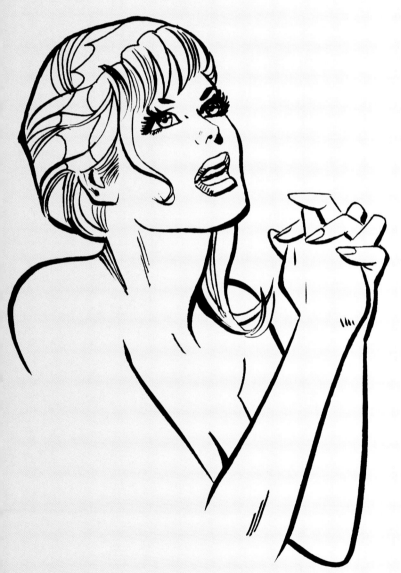

Clenched hands or interlocked fingers tell the reader that these women are doing more than making a simple wish for something. They are desperately begging and pleading—a much more powerful emotion.

Get the idea? Take it to the extreme. Be bold. You can always make adjustments if you think you've gone too far.

EXPRESSIONS

Have some fun with your readers. Make them try to guess what your babe is thinking even if there are no word balloons in the panel.

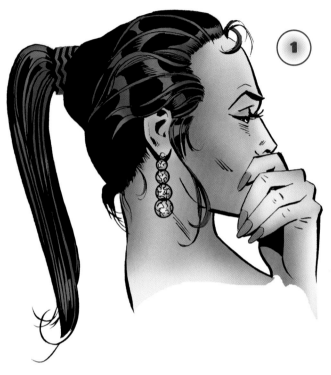

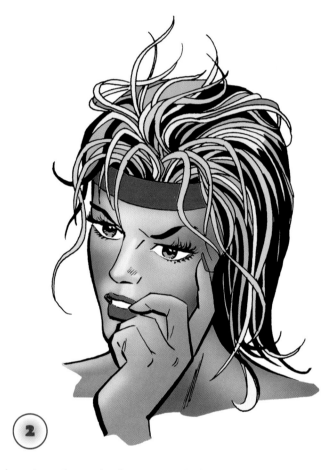

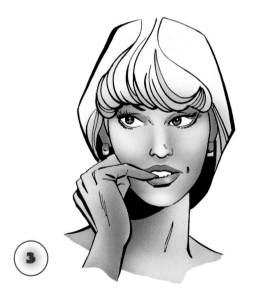

This heroine is in serious contemplation, no doubt about it (figure 1). Her thought balloon could be as simple as "Hmmm."

Another deep thinker at work (figure 2). You can almost smell the wood burning. Notice how a single, thin line at the eyebrow helps tell her mood. Get out of this gal's way! Her date has stood her up and he's in real trouble. Even though you can't see it, you can hear her toe tapping with impatience.

This blonde bombshell (figure 3) is befuddled. She may be thinking, "Should I or shouldn't I?"

MORE EXPRESSIONS

It all boils down to one simple trick: The hands work in coordination with the face to indicate expression. Where the hand rests is as important as its posture—the reader's eye will follow the hand, and that makes it an important storytelling device. Bring the hands to the face, add a suggestive expression, and you've established a tense situation—even if you have no more information.

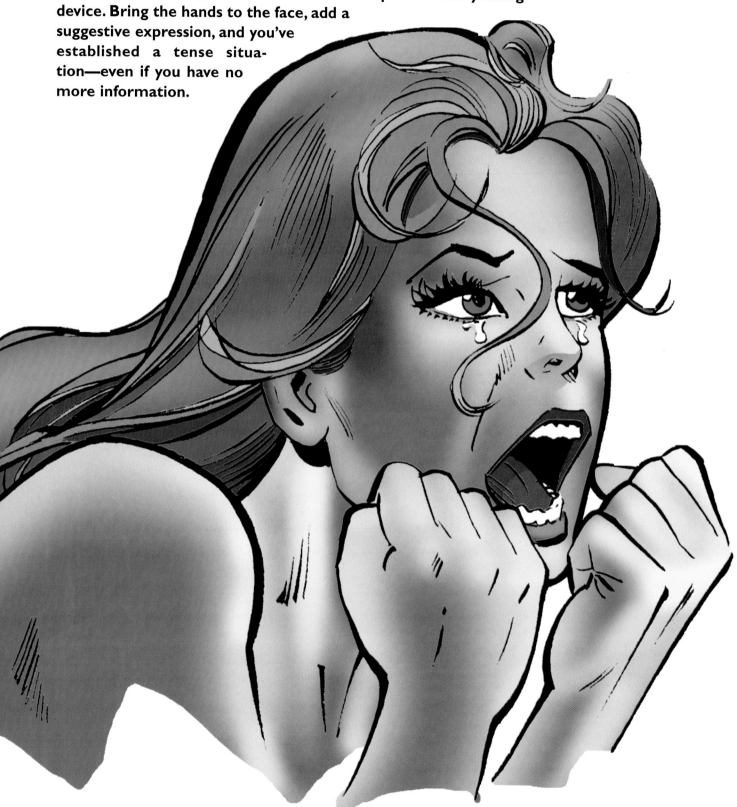

58

What does the hand say? Cover it with your hand. The face expresses helpless terror. Now take your hand away and look at the whole picture. How does her hand change your impression?

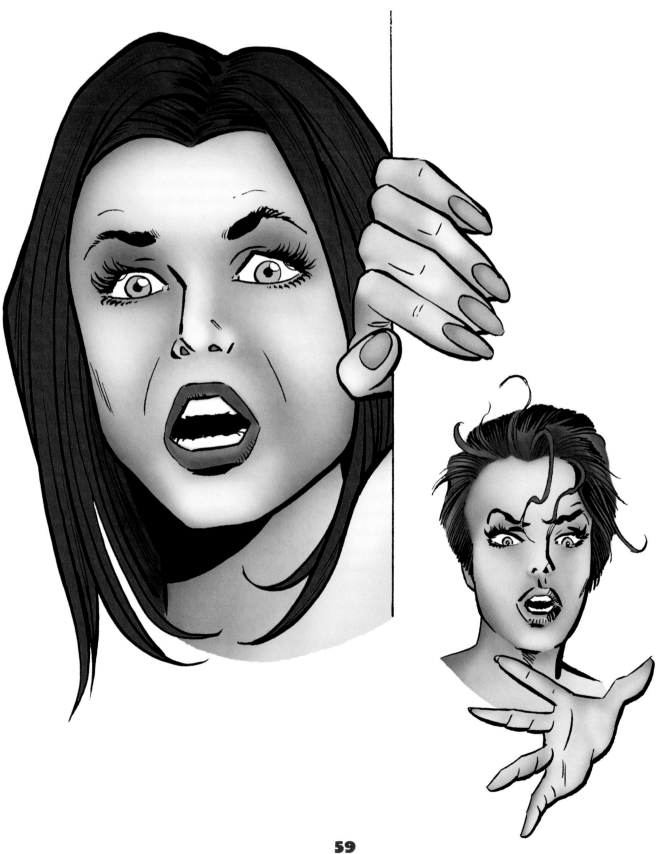

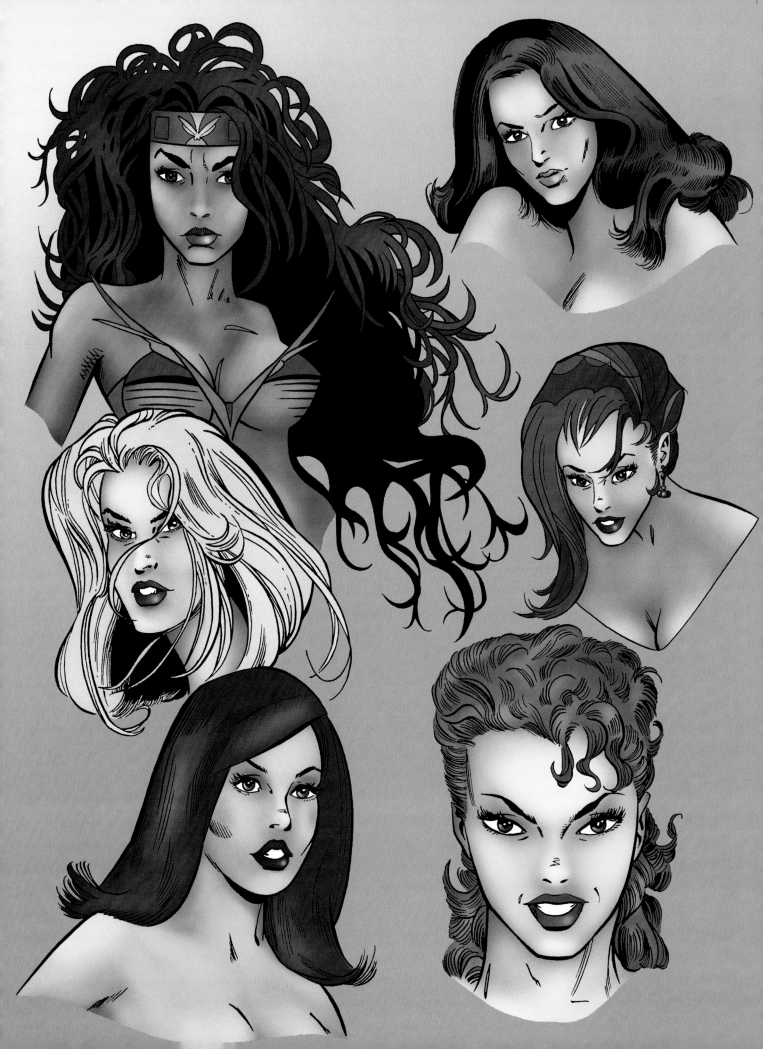

COIFFURES

In illustration as well as real life, certain hairstyles have stereotypes. Plain hair indicates a plain person; the latest cutting-edge cut is likely to suggest a trend-conscious character. Something never seen before will frame the face of an adventurous woman; something elaborate and time-consuming will be wrapped around a very definite and deliberate person.

So far we've been roughing-out the hair, paying more attention to the character's physical and psychological attitudes. The final hairstyle must reflect these considerations but, as noted previously, they will also modify the characterization. This symbiosis is unique to illustrated storytelling, so use it to your advantage.

HAIRDO CONSTRUCTION

After constructing the head, put in the shapes of the hairstyle. Once again, we always start with shapes. Locate the facial features (figure 1).

Pull some light pencil lines out from the scalp in the direction of her hairdo. (Draw these lines in the directions shown by the red arrows in figure 2).

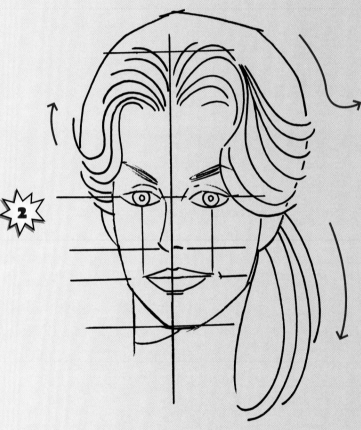

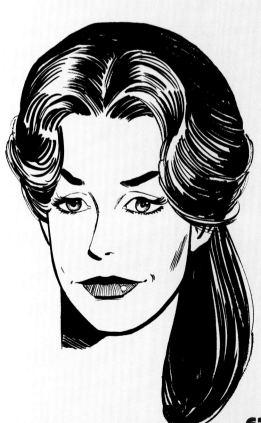

Establish your primary light source and determine how highlights will affect your design. For example, brunettes will have lighter or even open areas in their hairdos and these lighter spots will indicate the areas that are directly in the primary light source (figure 3).

A profile view (figure 1) gives your girl a chance to show off her long, flowing tresses.

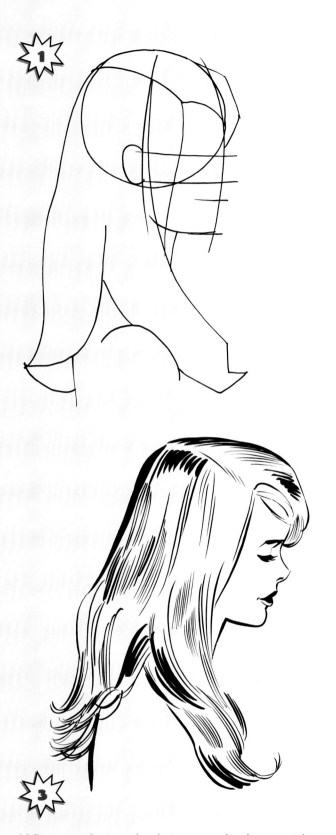

Give her hair just a little flip at the ends (figure 2). It helps create a perky look and keeps the hair from looking drab and flat—the flat hair that models in TV commercials are always complaining about.

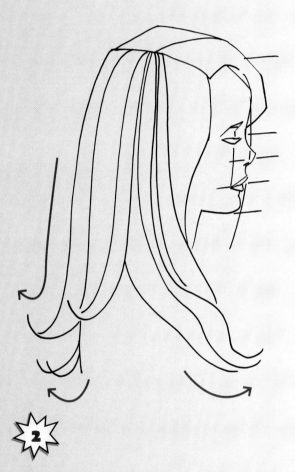

When rendering the hair, vary the line weights (thickness) to help create sheen (figure 3). This is particularly important for our Good Girls, who want to appear soft.

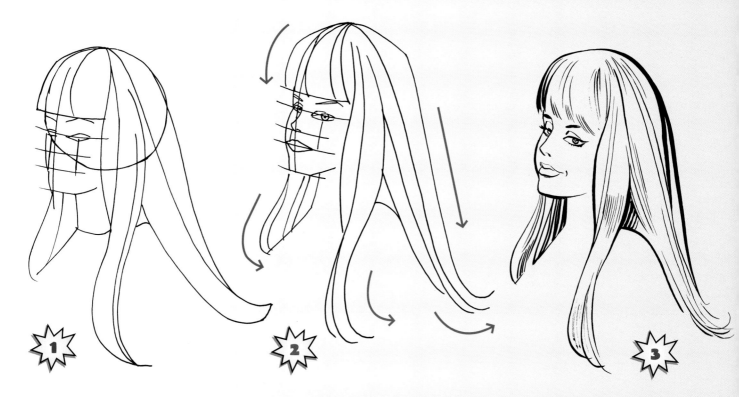

Above is our blonde-haired Good Girl, step by step. Start with basic shapes (figure 1), pay attention to the hair-growth direction lines that give shape and form (figure 2), and tighten with an appreciation of your light source, varying the line weights as appropriate (figure 3).

Below we've given you a head start on another Good Girl's hair. Finish figures 4 and 5 in pencil, and when you are satisfied with what you have, move on to figure 6 and design your own hairdo. Use a piece of tracing paper. This way, you can make all the mistakes you need to and still be able to try again with different hairstyles.

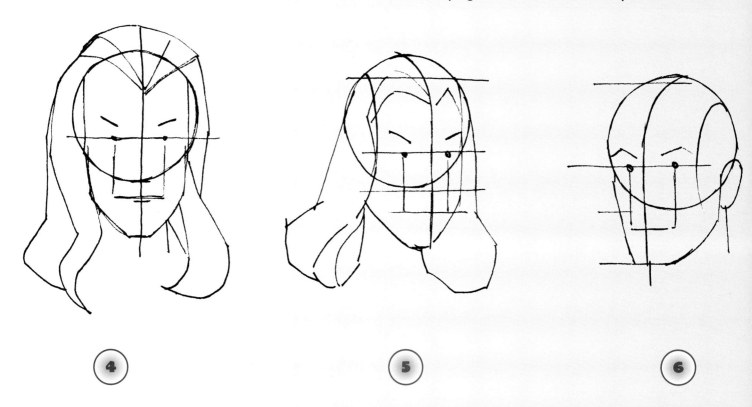

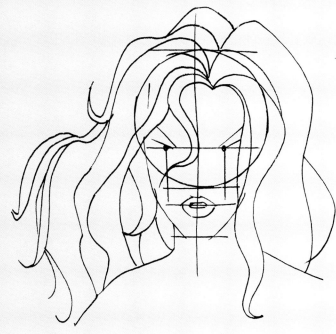

As always, the Bad Girls take more time and consideration. The basic procedure is the same, but the styles are more wild and unkempt (figure 1).

Those growth lines remain the same, but now you can take greater liberties. Remember the differences between Good Girls and Bad—what applies to the eyes is fair for the hair (figure 2).

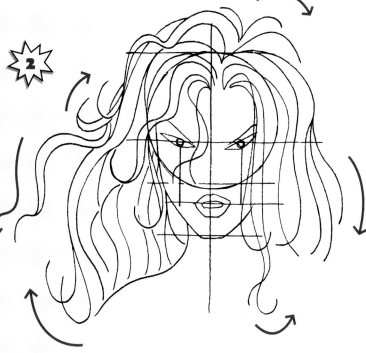

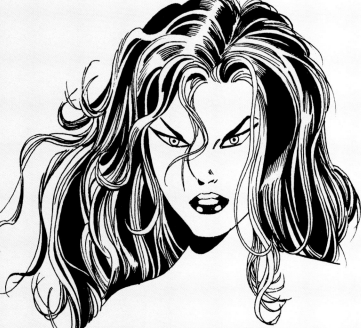

Feel free to check out the latest fashion magazines, but do not be afraid to experiment (figure 3). If all you do is copy what people have already seen, there will be nothing individual, unique, or particularly memorable about your work.

INKING TECHNIQUES FOR HAIR

Although we don't often see women with metallic hair in real life, we sure do in comics!
This inking technique creates a liquid effect as well.

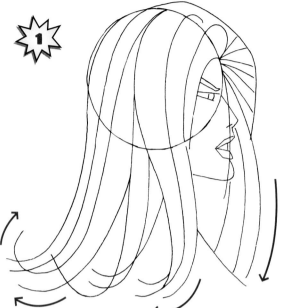

Once the hair has been drawn (figure 1), doodle in solid shapes wherever you see sharp angles (figure 2). Think of the patterns on feathers from colorful birds. Try some of your own inking effects.

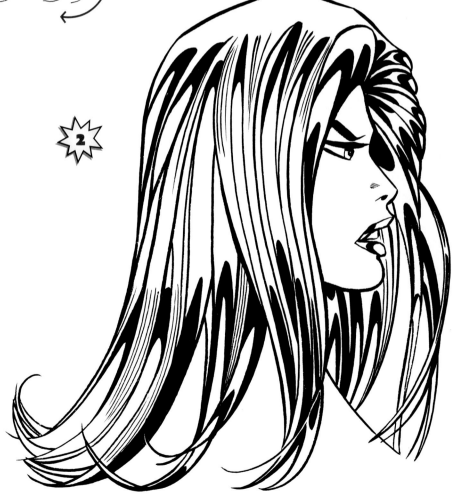

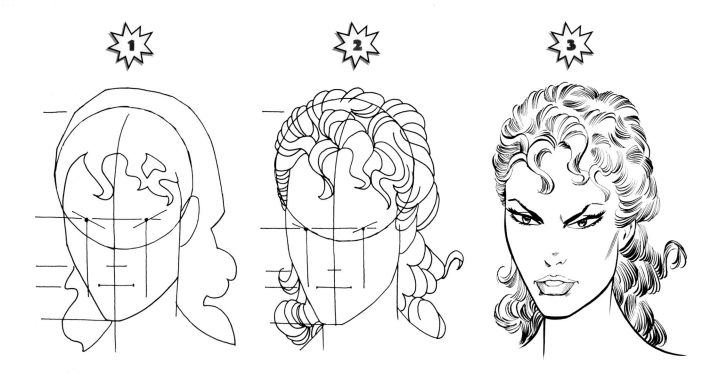

This blonde-haired Bad Babe has a short-cropped hairdo (figure 1). In the inking stage, we've given her a curly look to make that cropped hair more interesting (figure 2 and 3). With those harsh eyes, her evil inclinations are clear to the reader.

Below is your Bad Girl hairdo construction kit. Try designing two completely different hairstyles in pencil, using figures 4 and 5 as starting points. Figure out which one is more malevolent, then move on to figure 6 and polish it up in ink. (Don't forget the tracing paper.)

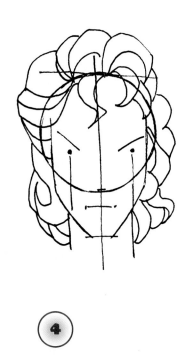

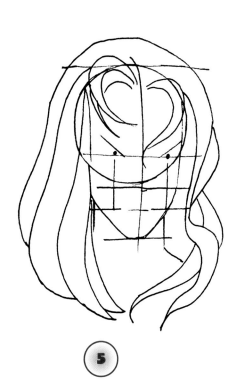

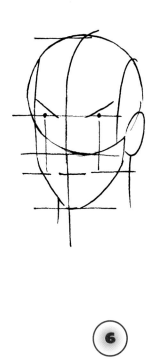

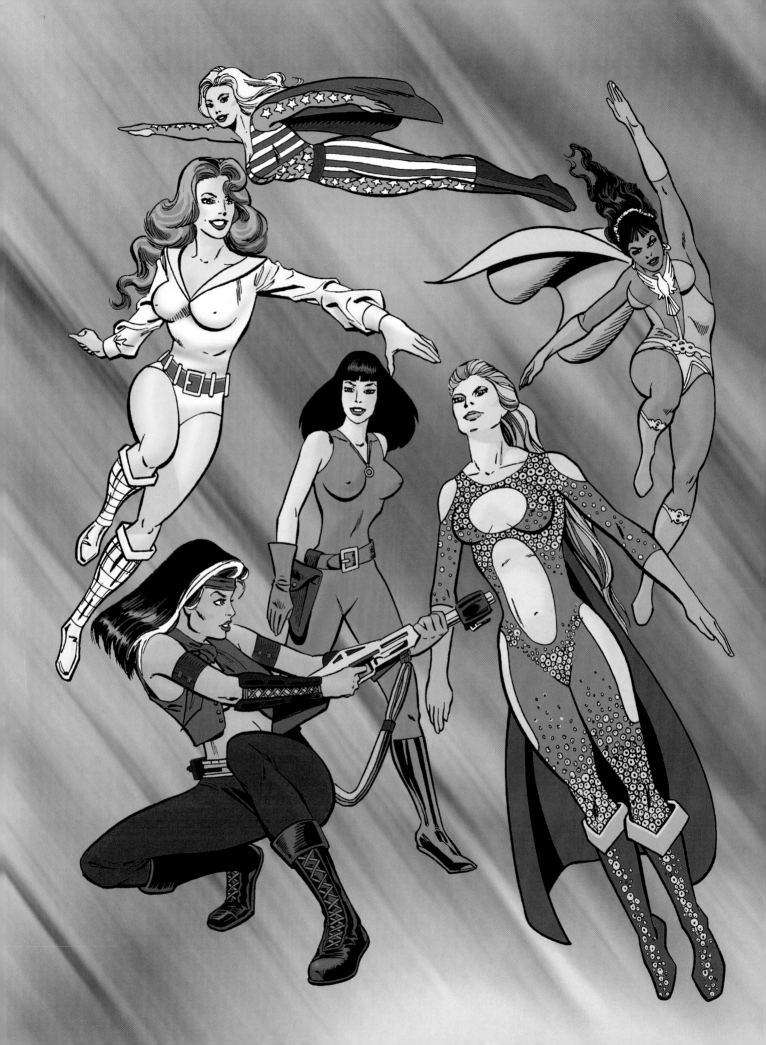

COSTUMES

This art form is larger-than-life, and a vivid imagination is as important in designing costuming and wardrobe as it is in every other element of your work. It is possible that what you create from your imagination can become dated, but it is less likely if the costumes are original.

When you approach your costume design, keep in mind that it will have to look good in motion as well as in a static, "poster" shot. Draw your basic figure in perspective and refer to the body charts on pages 12 and 13. Rough-in the hairstyle. As shown in the previous chapter, it will have an impact upon your wardrobe, and you might want to alter the hairstyle a bit to work with your costume design.

COSTUMES AND THE VANISHING POINT

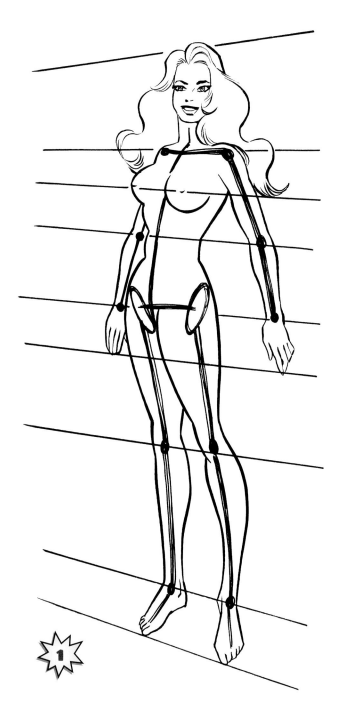

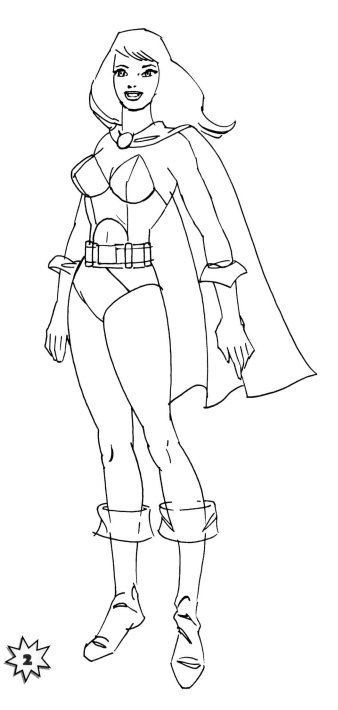

This patriotic damsel is standing at a slight angle, and because our eye level is about at her waist, we need guide lines to put her in perspective (figure 1). Believe it or not, these guide lines all meet at a single point, called the "vanishing point," way off the edge of the page. We'll talk more about the vanishing point later.

Without concealing too much of the body, sketch in some clothing (figure 2).

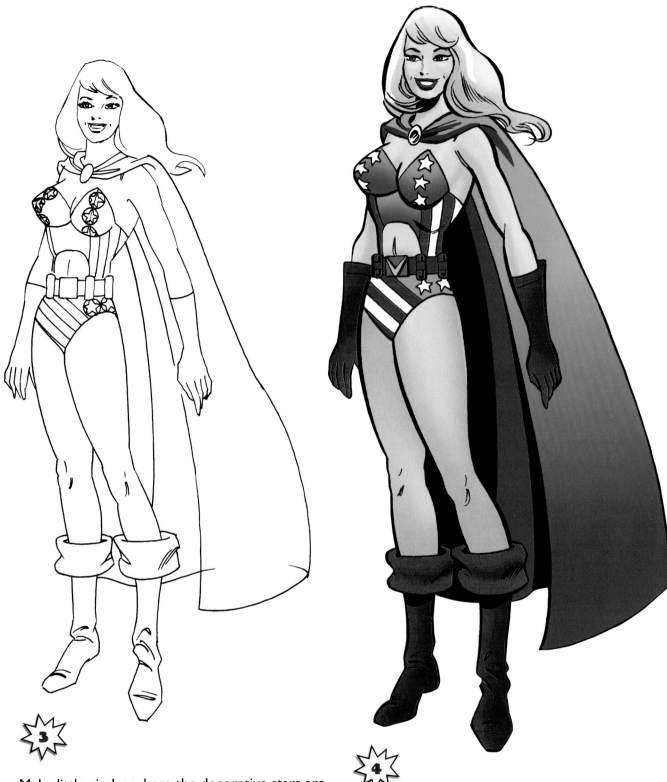

3

Make little circles where the decorative stars are to be drawn (figure 3). Begin to add other details and add some black areas as well.

4

We weren't happy with the short cape and ugly hair from figure 2, so in figure 4 we lengthened the cape, added a fluffier-looking hairdo, and wiped the dopey look off her face. Now she's ready to battle the baddies for the good old U.S. of A.

A BAD GIRL COSTUME, STEP BY STEP

As each element fits together and you grow more satisfied with your design, continue to tighten your pencil art until you're ready to ink.

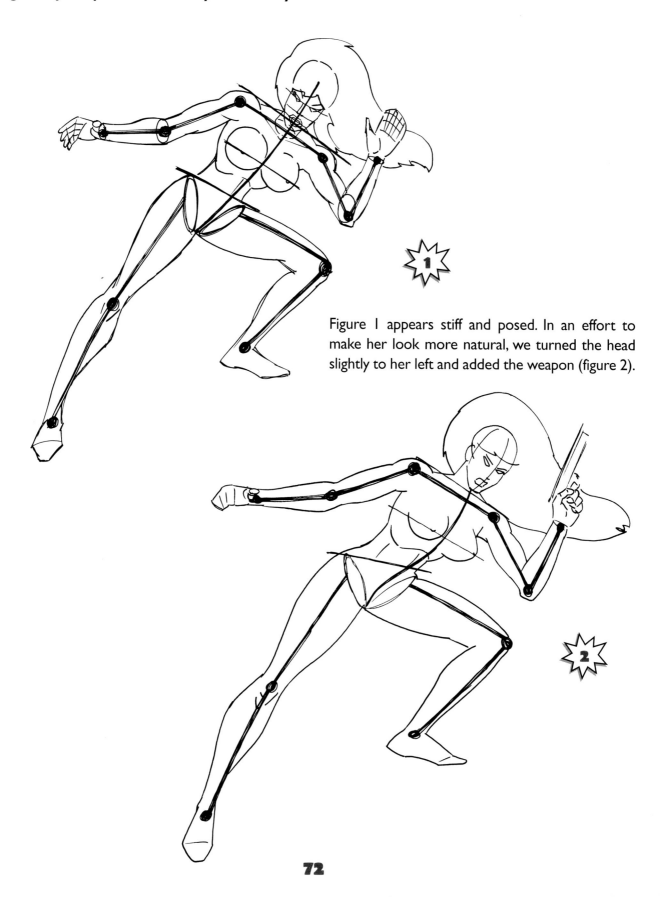

Figure 1 appears stiff and posed. In an effort to make her look more natural, we turned the head slightly to her left and added the weapon (figure 2).

Note how she now has a more free-flowing hair-style, creating a feeling of action (figure 3). She's also well-armored and has a much more power-ful weapon.

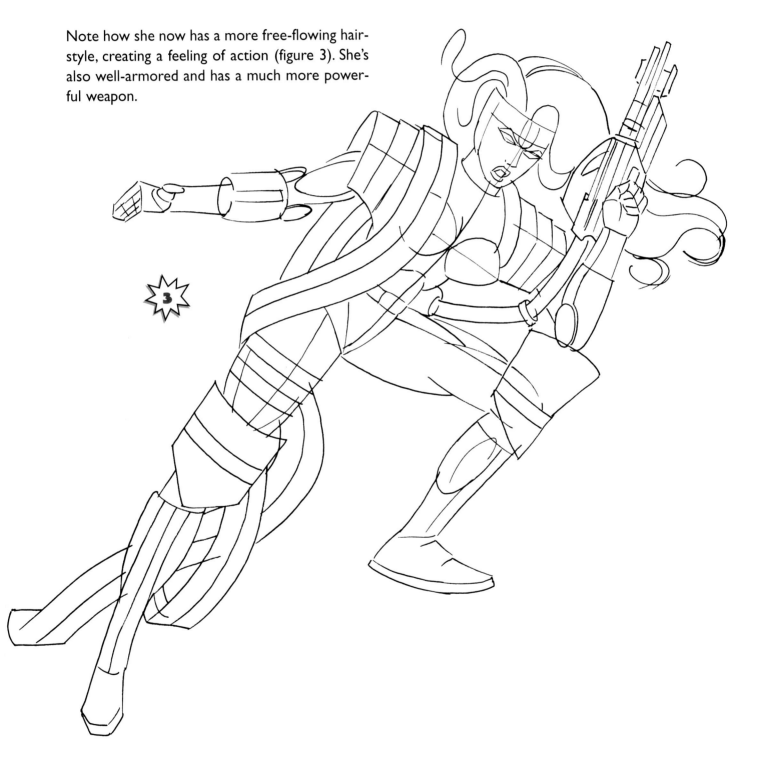

Remember to keep textures in mind—kevlar, leather, hair—during the pencil-tightening stage, so there will be no confusion when the drawing is inked (figure 4).

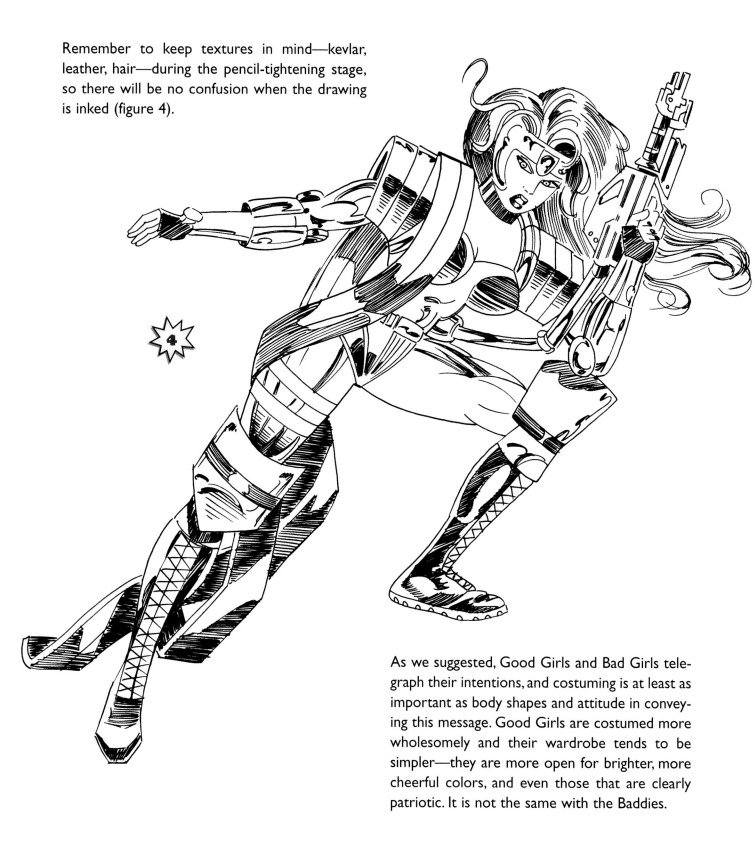

As we suggested, Good Girls and Bad Girls telegraph their intentions, and costuming is at least as important as body shapes and attitude in conveying this message. Good Girls are costumed more wholesomely and their wardrobe tends to be simpler—they are more open for brighter, more cheerful colors, and even those that are clearly patriotic. It is not the same with the Baddies.

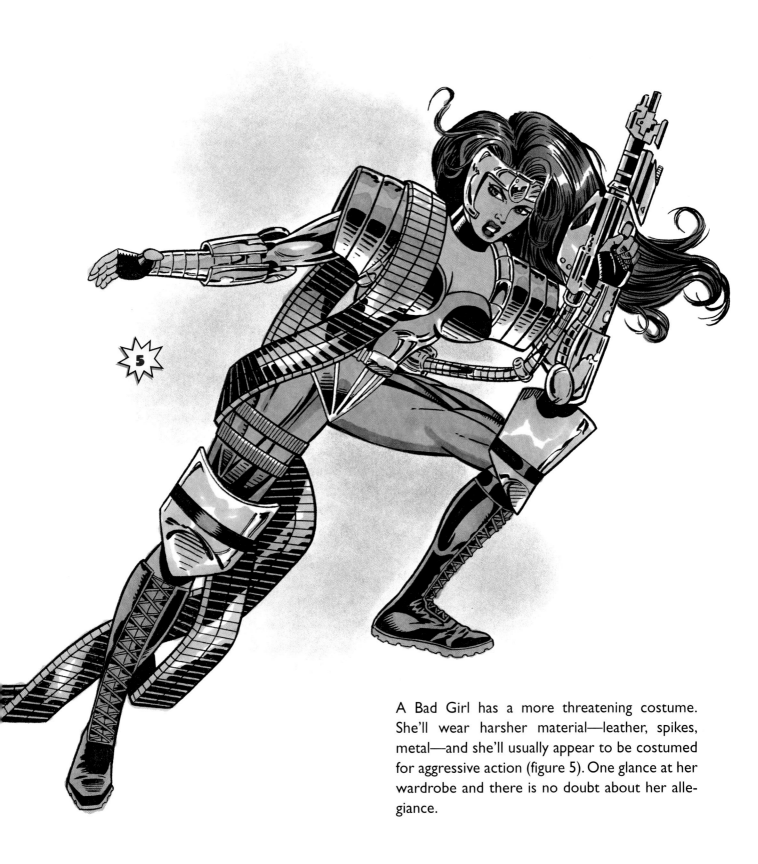

A Bad Girl has a more threatening costume. She'll wear harsher material—leather, spikes, metal—and she'll usually appear to be costumed for aggressive action (figure 5). One glance at her wardrobe and there is no doubt about her allegiance.

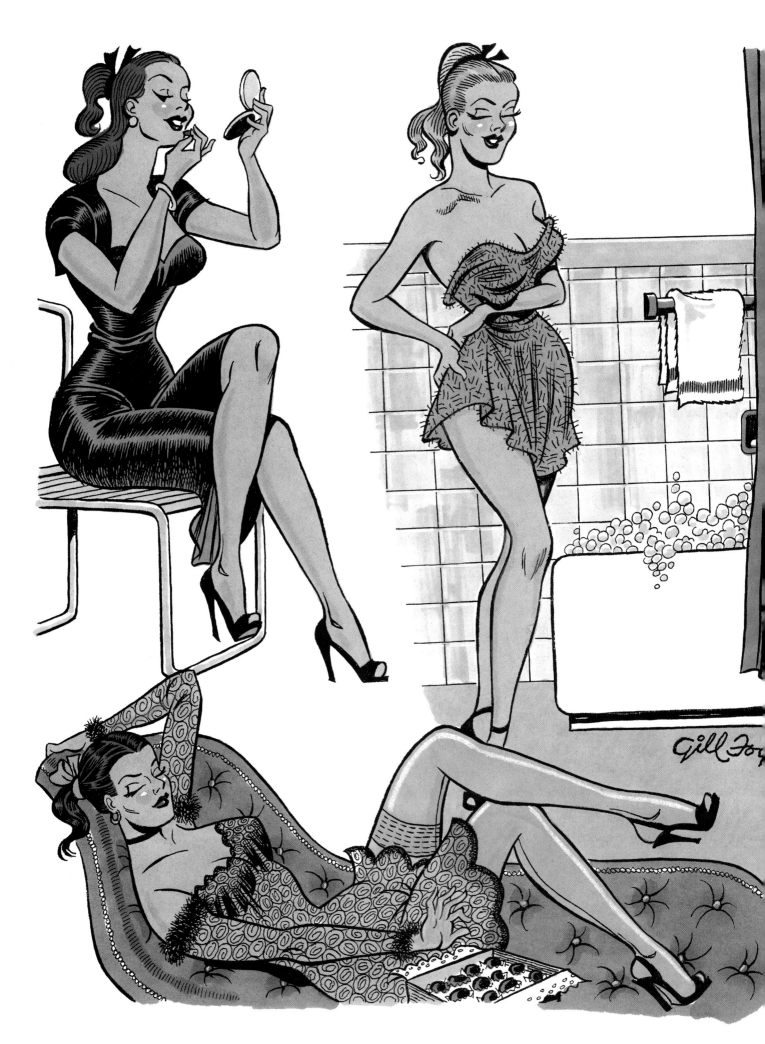

MANGA AND PIN·UP ART

The new and never-before-seen always carries a certain excitement for the reader, but jumping into something cutting-edge or trendy is risky business: fads and trends have a shelf life, and you don't want your work to look dated the day after it comes out. On the other hand, it never hurts to nourish your own work by studying something completely different.

We've been following an artistic movement that we're happy to say looks like a keeper; after all, it's only been popular for about five decades—in Japan.

Manga—Japanese comic books—started to become a separate and unique storytelling force in the years following World War II. The evolution of Japanese comics is a rich and fascinating story; we highly recommend Frederik L. Schodt's *Manga! Manga! The World of Japanese Comics*.

Manga serves as fuel for the Japanese animation industry (anime), and manga designs, characters, approaches, and influences serve as the ground floor of the video game business.

The art form deserves to be studied in depth, but there are two important elements we wish to share with you here.

- Manga entertains people of all ages and sexes—there are Japanese comic books for venerable grandmothers and for preliterate toddlers.
- Manga constitutes more than one-quarter of all books and magazines sold in Japan. They are sold everywhere: in vending machines, at subway stations, in bookstores, and at neighborhood convenience shops. There are far more comic books sold in Japan than in the United States.

With the success of *Akira, Sailor Moon, Astro Boy,* and *Grave of the Fireflies* (and that's a range of content that is quite broad indeed), Japanese-style storytelling art has become a major influence on the east side of the Pacific. So when it comes to incorporating these influences into your work, here are a few tips: Japanese-style figure work is cute, youthful, and usually less detailed. People smile more, and their eyes suggest wonderment. By American standards, the work appears "cartoony," and we tend to view that as something that should only appeal to children. There are tens of thousands of Japanese adults willing to put this theory to rest.

THE MANGA BABE

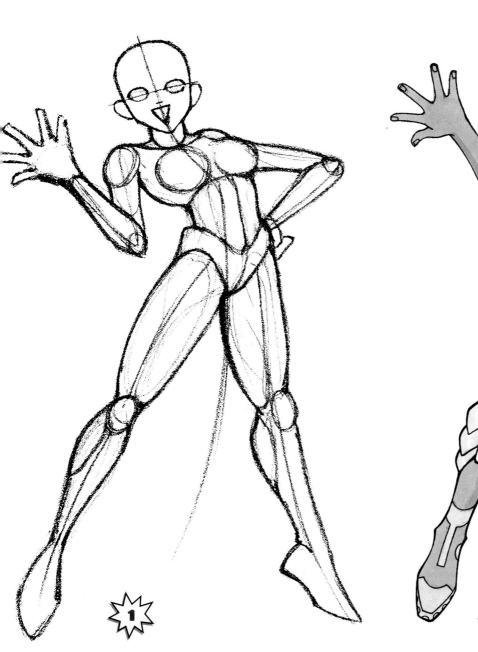

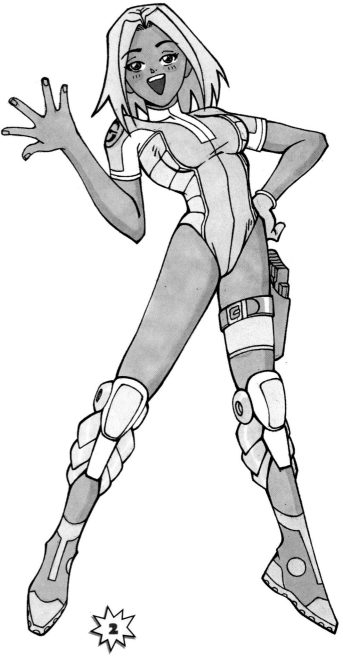

In creating the basic figure, the breakdown is basically the same as that of the Western-style character, except that the head, hands, and feet are noticeably larger. The manga character is a little over $6^{1}/_{2}$ heads tall, as opposed to the Westerner's 8 or 9. It is the large head size that throws this off. She is also extremely flexible. Look at the curve of this spine (figure 1).

Avoid adding too much detail; it is not in keeping with manga traditions and it tends to give your characters (particularly women) a more aged look. This places greater weight on the posing of the characters themselves: What you cannot suggest in the costuming, you can connote in the pose and the way the character occupies its space. The process of focusing the attitude on the pose itself is foreign to Western artists, but it is a valuable and exciting device (figure 2).

THE MANGA FACE

In Japanese storytelling, the eyes are extremely expressive and are almost always fully visible. They are often seen through the character's hair. One of the most popular effects is to drape the hair around the eye, particularly in an extreme close-up.

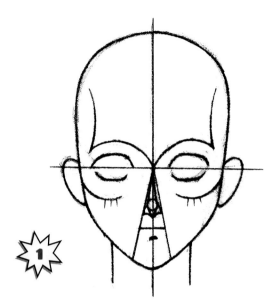

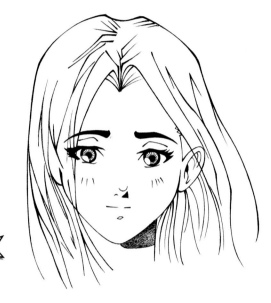

The head is not quite egg-shaped; the eyes are placed a little lower than halfway down and, due to their size, are placed farther apart to avoid a cross-eyed look (which is reserved for comedic or extreme effect).

The nose is the least important facial feature, particularly with women, and is generally drawn to be small and unobtrusive (figure 1). Overall, the bigger the eyes and the squatter the head shape, the younger the character will appear (figure 2).

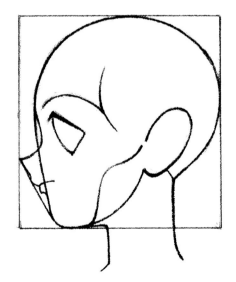

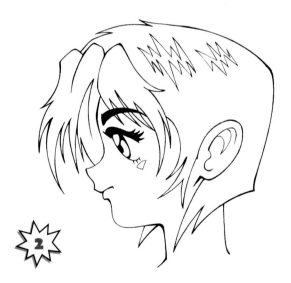

The profile of the manga character is usually anatomically incorrect. Everything is there, but everything is exaggerated: eyes and ears are larger, and the nose and mouth are smaller.

You can draw a straight vertical line from the tip of the nose to the tip of the upper lip for Western figures, but in manga that just won't work (figures 1 and 2).

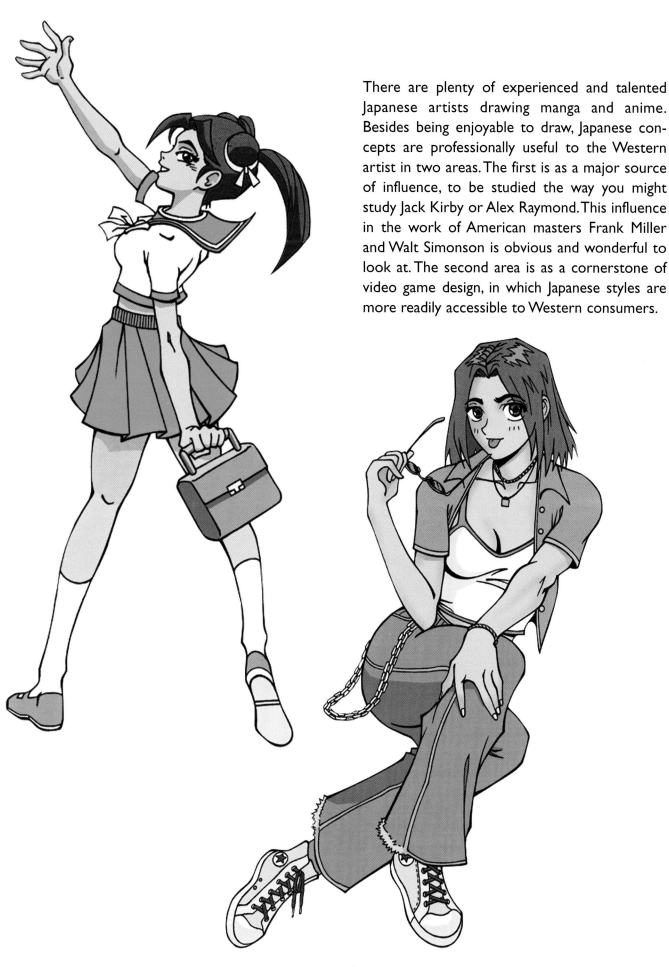

There are plenty of experienced and talented Japanese artists drawing manga and anime. Besides being enjoyable to draw, Japanese concepts are professionally useful to the Western artist in two areas. The first is as a major source of influence, to be studied the way you might study Jack Kirby or Alex Raymond. This influence in the work of American masters Frank Miller and Walt Simonson is obvious and wonderful to look at. The second area is as a cornerstone of video game design, in which Japanese styles are more readily accessible to Western consumers.

PIN•UP ART

You can learn a lot not only by looking outward, but also back in time for styles that may influence you. The illustration of attractive women has been part of every artistic movement since cavepeople invented interior design, and there was a particular desire for pin-up art during World War II. For half a decade, millions of male soldiers spent an overwhelming amount of their time completely or largely separated from women. The only opportunity for their hormones to enjoy a memory rush was in little joke books and magazines. The pin-up art movement solidified, and masters like Vargas and Petty became its patron saints.

Early in his career, artist Gill Fox realized that "pretty girl" art was becoming a very big part of cartooning. Fox was a popular comics artist in the 1940s who was perhaps best-known for his work with Quality Comics, arguably the best line of comics during the so-called Golden Age. Among his many achievements, Gill worked on the standard-bearer of Good Girls, Torchy—the extremely popular, late-1940s "blonde bombshell."

Gill soon discovered what works: The ideal beautiful girl should be like the one shown here, 8 1/2 heads high to indicate a feeling of graceful elegance. This served as the cornerstone for an approach to body language—that element that is so important in real life (we communicate through body language), but so hard to translate into two-dimensional line art.

The first rule is elegance. The second is to remember the need for exaggeration. Exaggerate eye size, high bosoms, lots of well-shaped hair, short waists, longer calves, thinner ankles—all are important elements in creating an elegant look.

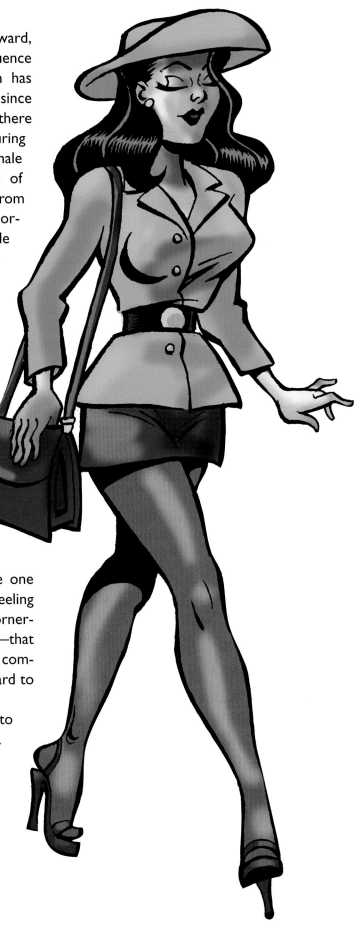

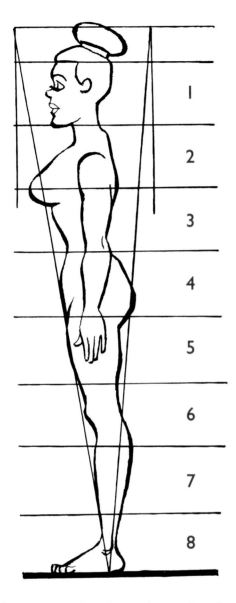

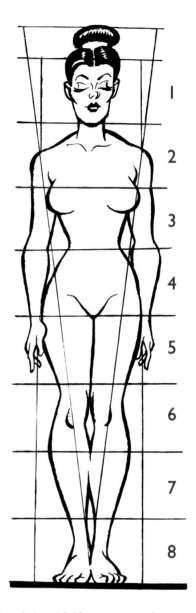

Keep the pretty girl perky, wide-eyed, and appealing. Poses were more theatrical in the Age of Elegance; today, women's poses are more self-assured and powerful.

Body language is like timing: you can only learn it by example. Think style, think elegance (and there is such a thing as evil elegance) . . . and go to the movies!

The look of the 1940s pin-up gal is created by a tilt of the head, pouting lips, flirtatious eyes, high cheekbones, and a long neck. Such elegance is not dated. It is a style, a look that can be adapted to all times and fads. It creates a body language that suggests—depending upon the surrounding story—intelligence, refinement, style, attractiveness, and seduction.

When you watch a pretty model walk, you realize how important moving action is to a beautiful figure. Costuming is very important—a tight waist, a long neck, and an uplifted head emphasize and frame a pretty face.

THE MASTERS OF PIN·UP ART

Two of the absolute all-time masters, Milton Caniff and Will Eisner, seem to have spent more time at the movies than behind the drawing board. Caniff created *Terry and the Pirates.* Eisner created *The Spirit* in 1940, and today is America's leading graphic novelist. Both men—and many others (like Steve Canyon, creator of the *Dragon Lady*)—have studied the movies, and their women, to enormous effect. Three-dimensional body language can be translated into the two-dimensional world of graphic storytelling, as well as the "two-and-one-half"–dimensional world of video games and Internet sites.

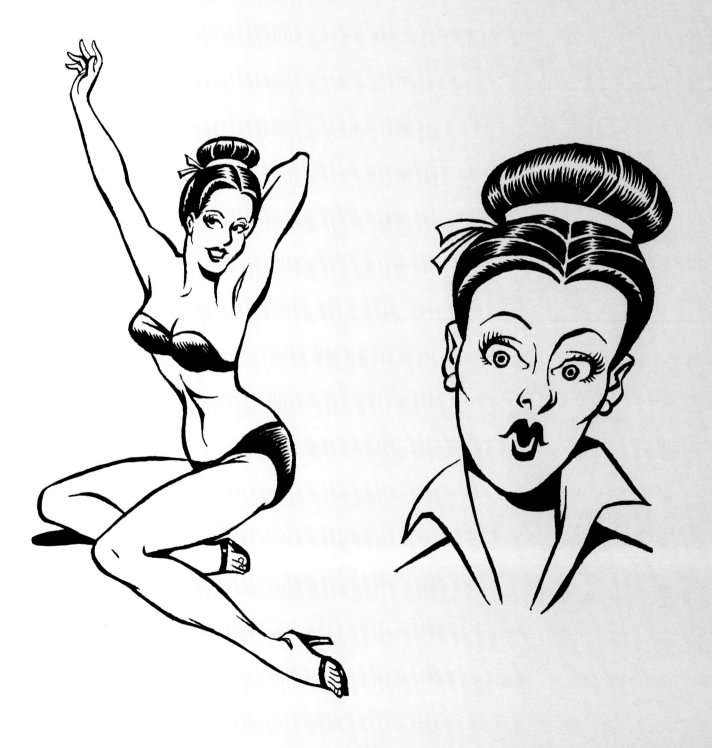

STUDYING BODY MOVEMENT AND MOTION

Your study of body language and motion will be enhanced by some old-fashioned girl-watching. There is no substitute for real life. If you want to know how people move, watch them move. Remember all of the elements we have introduced in this book, and take note of how they all fit together in a functioning human being. Don't forget to bring your sketchpad. Note, for example, the way women stand and walk in high heels like those worn by the women below.

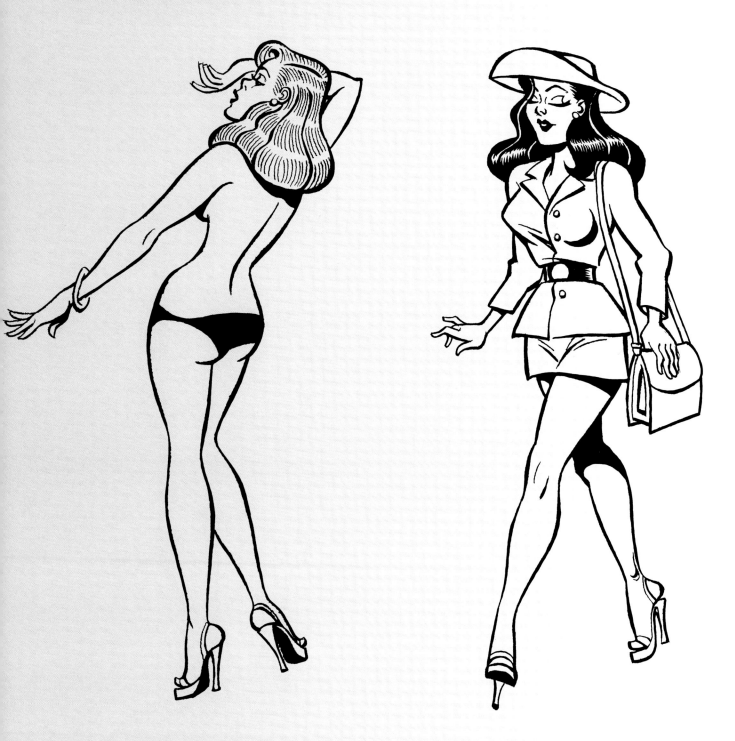

TECHNIQUES

Robert Crumb (creator of *Mr. Natural*) said it best: "Hey, kids! It's all just lines on paper." Of course, he said that in the late 1960s; today, it's all just dots on paper or on a monitor screen. Millions and millions of teensy, tiny little dots. Lots of dots combine to form line, weight, color, and shape. They define negative space as well. So it is our task to reproduce the wonderment of our three-dimensional world with merely two-thirds the number of dimensions.

We have to use halftones with line art (halftones are the gray areas between pure black and pure white) and create the illusion of depth with the techniques we have available to us. There is an unlimited number of techniques, and discovering how other artists approach their problems is quite educational. It's also a great way to blow deadlines, so watch it. Start off with these basics, and you'll be noodling, experimenting, and developing your own techniques before you know it.

1. Straight lines—thin, medium, and bold. You probably figured this one out already, but the thickness of your line defines dimension and personality. Thicker lines can suggest the object is closer to the "camera." They can also indicate a bolder personality or a more imposing object.

2. Varying line weights: Thick and thin lines using a brush (in this case a Windsor-Newton watercolor brush, Series Seven, No. 2). This is critical: by varying your line weights, you will create the illusion of depth and perspective while at the same time defining the personality of the object.

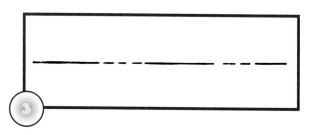

3. The broken line: It is usually ruled, but it can be drawn freehand as well.

4. The "dry brush": Notice how the top of the line remains relatively straight while the bottom is rough and uneven. To get this effect, hold your brush at a low angle to your paper and draw the line quickly. Use rough paper.

5. "Nervous lines": Here are three using a Gillot No. 170 pen point. By exerting different pressure on the pen you'll get a different line thickness.

6. Ruled lines with a stiff croquille pen point: This technique may take some practice, but it is used to create a casual but controlled look. We often see this in advertising art. Note the slightly overlapped corners and the heavier but casual line at the base.

7. A simple crosshatch pattern drawn with a stiff pen point. This crosshatch goes in three different directions: straight, 45°, and 135°. This allows for the creation of depth as well. You can learn to make a graded wash by making your lines farther and farther apart.

9. Take an old brush and barely dip it in the ink. Hold it vertically and tap the paper lightly, rotating the brush with each stroke. This technique is quite effective when rendering trees, shrubbery, and weird outer-space or extra-dimensional effects.

11. Wood grains should not be overdone. Suggest the direction of grains and add a few whorls and knots, but keep it light and let the color do the work.

13. Bricks and stonework are important for creating the illusion of buildings, fences, and cities. Pay attention to your light source—when you light your scene for its storytelling, remember that it will cast shadows on the far and bottom side of each brick or stone. Add a few dots to each brick to suggest the texture.

8. You can create a different type of graded wash by using varying pressure to go from dark to light. Be sure to make your rows of lines very uneven and ragged.

10. Apply a light amount of ink to your thumb and stamp it along the edge of dark smoke or clouds. This takes practice, but it's very effective.

12. Ruled lines, from thick to thin, describe a gradual change in value. This can be done more precisely on your computer, but that will give you a colder look.

PHOTOGRAPHY

Another technique for creating the illusion of reality is to take photographs using your own models. These photos won't see print, so use an instant camera that will allow you to make immediate corrections and reshoot. If you're using a digital camera, get one that allows you to see the photos in the camera before you download them onto your computer. Trash the ones you don't want before you download; it'll save time. Megapixels aren't necessary, and you don't have to print out your shots on photo-grade paper. Of course, you can create effects and alterations on your digital photos prior to printing.

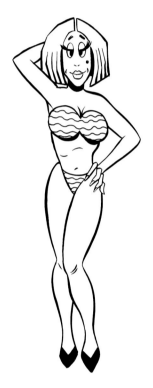

Here are a few tips:

- Eye level should be at knee level. Any angle above that makes the model's legs look short and stubby. That's what's wrong with this photo. Her figure as a whole becomes foreshortened. Try moving away from the model and drop to a level around her knees. Now her legs should look long and willowy (see opposite page).
- Your model's clothing should be midvalue in color. White or very dark clothing is hard to draw because you can't see all the fold lines or shadows.

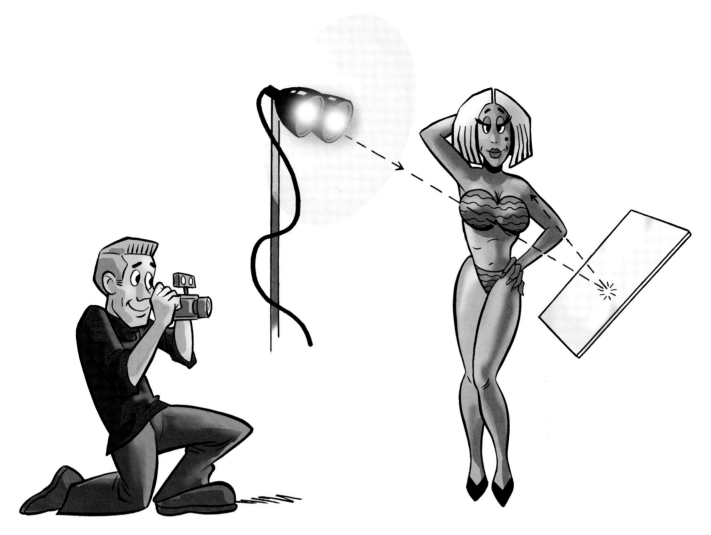

- Use a large white board on the dark side of the model so that it reflects the light back onto the model.
- Discard your photos after you're done so you won't have the temptation to use them again.
- Don't slavishly copy or trace photos if you want to keep a loose, natural look to your work. Remember: Line art creates the illusion of reality; photographs represent reality itself. Keep working toward a look of your own.

BRINGING YOUR PHOTO TO LIFE

Now you can take your photos and turn them into a new art form.

Figure 1 is an example of a cold tracing of a photo—it is merely a beginning that must be shaped, molded, and textured into a breathing piece of artwork by adding lines to suggest detail and life. We'll show you how in a couple of pages.

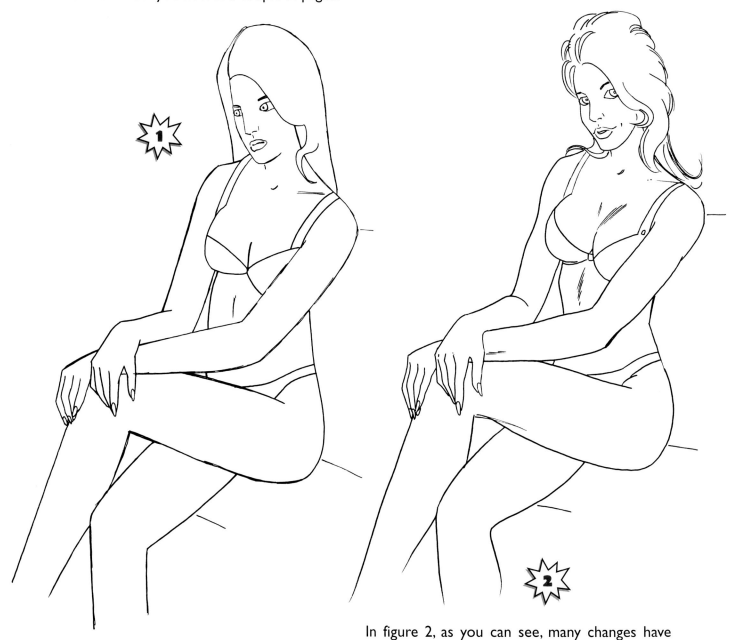

In figure 2, as you can see, many changes have been made. Some are barely perceptible to be sure, but they've added more dimension, energy, and life.

She is sweetened up even more in figure 3 when she is inked. A black-tip razor-point marker is all you need (Pilot brand).

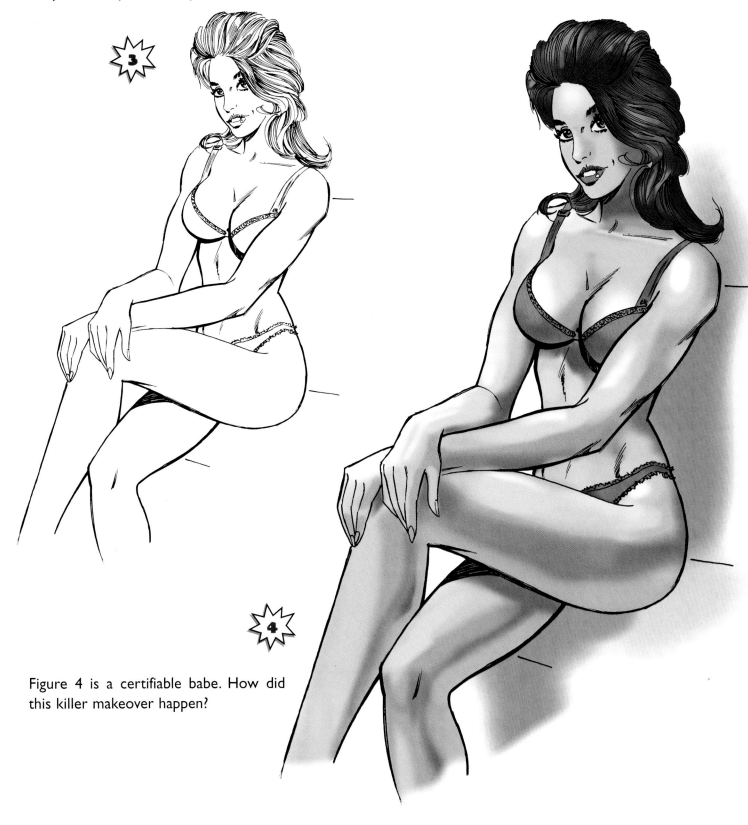

Figure 4 is a certifiable babe. How did this killer makeover happen?

BRINGING HER HEAD TO LIFE

Changing this rather plain-looking Jane into a voluptuous, enticing woman is not nearly as hard to do as you might think. Let's start with her head and begin some painless plastic surgery.

Look for the same trouble spots no matter whose face you are drawing.

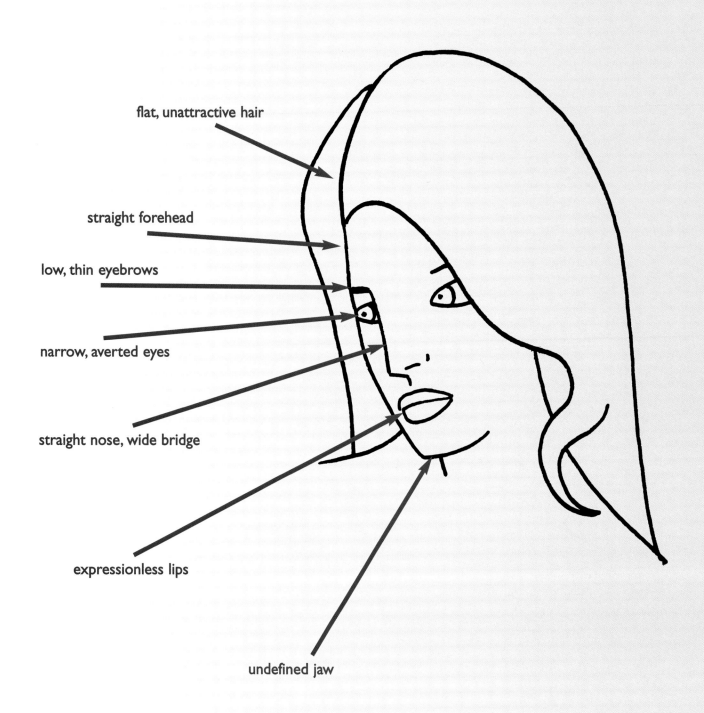

flat, unattractive hair

straight forehead

low, thin eyebrows

narrow, averted eyes

straight nose, wide bridge

expressionless lips

undefined jaw

After some simple changes in shapes, you have completely changed her appearance.

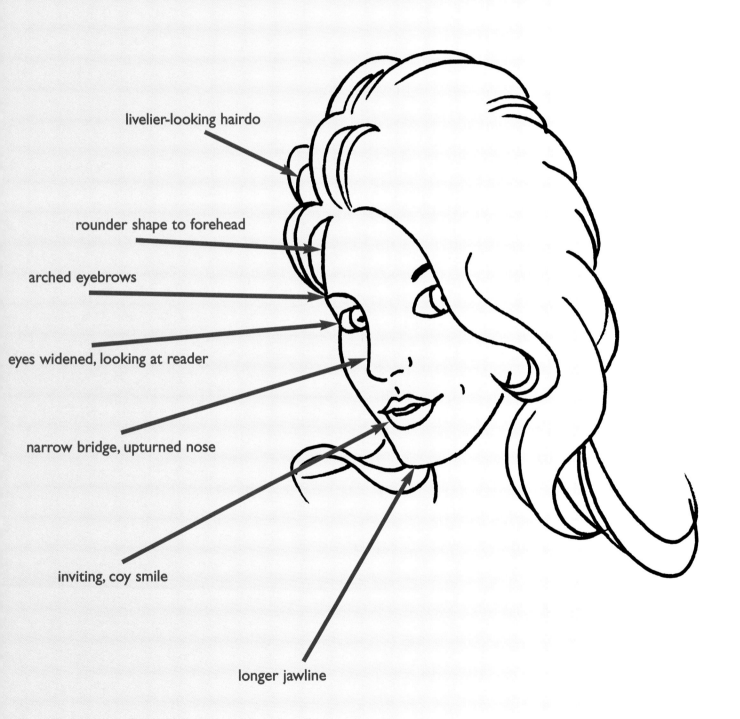

livelier-looking hairdo

rounder shape to forehead

arched eyebrows

eyes widened, looking at reader

narrow bridge, upturned nose

inviting, coy smile

longer jawline

BRINGING HER BODY TO LIFE

As you move down to her torso, you'll see many problems, but all are easily fixed. The secret is knowing where these problems will probably appear, and to anticipate them. With experience, you could make these adjustments with your eyes closed, but why would you ever want to?

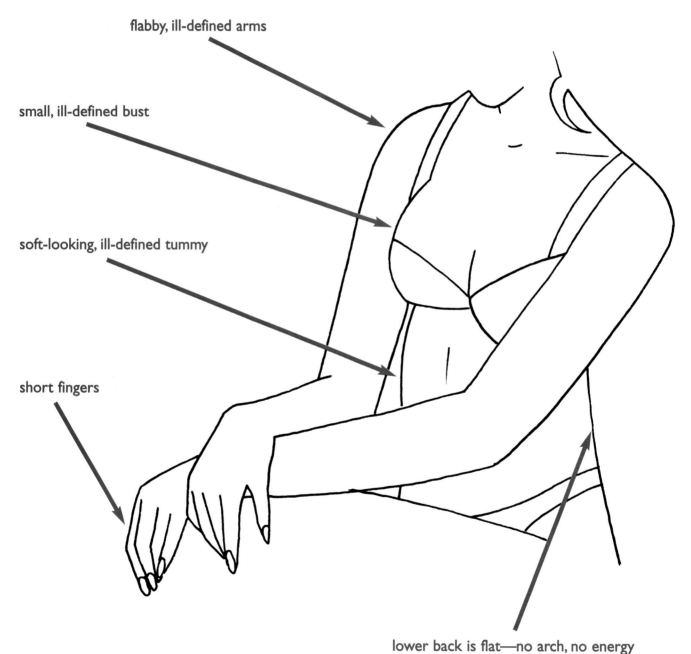

flabby, ill-defined arms

small, ill-defined bust

soft-looking, ill-defined tummy

short fingers

lower back is flat—no arch, no energy

Define muscles a bit, be careful here not to overdo it.

Uplift and enhance bust, indicate some shadow above bust.

Get rid of tummy; it also creates a more erect posture.

Lengthen fingers and nails.

Most importantly, curve that lower back.

BRINGING THE LOWER BODY TO LIFE

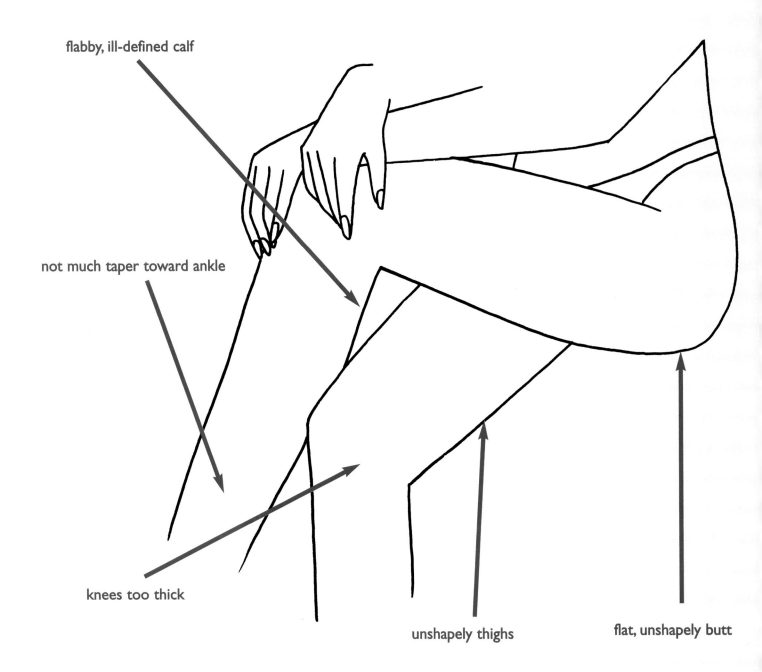

flabby, ill-defined calf

not much taper toward ankle

knees too thick

unshapely thighs

flat, unshapely butt

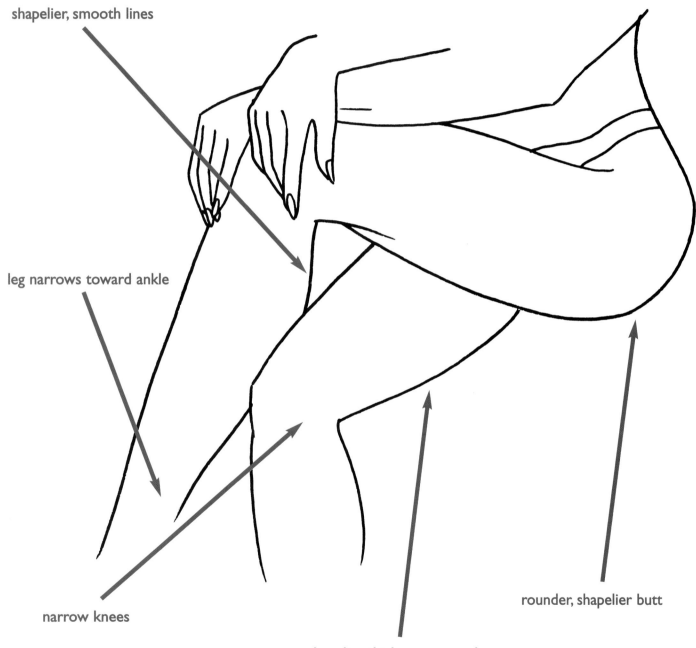

shapelier, smooth lines

leg narrows toward ankle

narrow knees

shapelier thigh, more muscle

rounder, shapelier butt

BACKGROUNDS AND BREAKING IN

Why the heck would we call this chapter "Backgrounds and Breaking In"? Hang on—in a minute we'll let you in on a great opportunity.

The importance of backgrounds is obvious: Simply drawing the important foreground stuff is lame. Backgrounds set the situation, put the characters in an environment, create expectations and tension, and set the atmosphere. That gun on the floor, those bats flying around the cemetery, the rain pounding on the window, the gown lying at the foot of the bed . . . backgrounds suggest mood and foreshadow events.

But we're teaching you how to draw Bodacious Babes and, with luck, how to make a living at it. That's where the "breaking in" part comes in. Most established artists find drawing backgrounds to be the least exciting part of their job.

Traditionally, overworked artists reach out to talented newcomers whose services they can readily and cheaply exploit. Less talented or untrained folks do the erasing or fill in blacks, but newcomers get to be called "assistants," and assistants do backgrounds. Hey, it's a start.

PERSPECTIVE

Background artists need to know how to use a T-square and triangle. This gets complicated, but from time to time you'll need to draw all sorts of straight lines, and these babies will help do the trick. Line up the T-square on the left side of the drawing board, plop your triangle on the straight edge, move it into position, whip out a pencil, and go nuts.

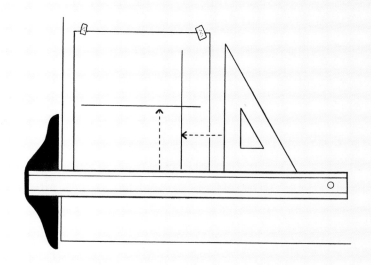

Establishing location and perspective is a bit tougher. Parallel lines exist only in two-dimensional space, or when you're looking at something straight-on. "Worm's eye view" shots need to be dropped back in perspective. You've probably learned all of this in art school or in your basic "how to draw" books, but here's the quick refresher course so you don't forget.

You establish your horizon line—that's the line past which all objects appear to fall off the edge—and you set your vanishing points at convenient spots on that line. In our little cityscape, all the north-south streets come out of one of the vanishing points, and all the east-west streets come out of the other. You've established an instant perspective.

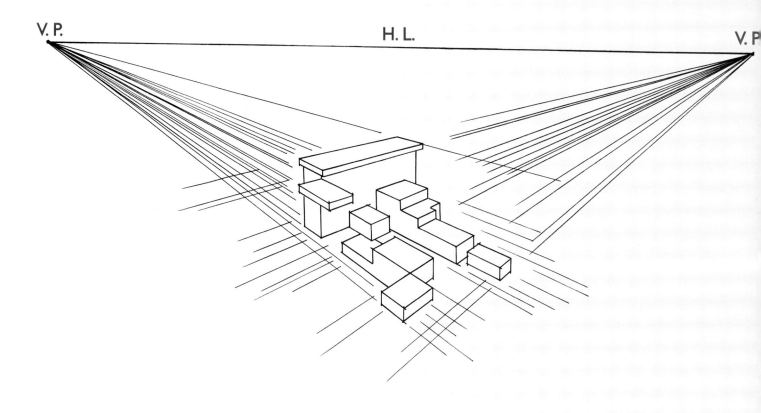

THE VANISHING POINT REVISITED

You can also create perspective starting at a single point. The tile floor is a great way to get proper placement of things in an environment—people and furniture in a room for example. All of the up-and-down lines meet at the vanishing point, which is on the horizon line that is usually extended well past the room's rear wall. The various background levels are established by lines parallel to the horizon line, and the wall on the right is established in perspective by drawing lines perpendicular to the lines parallel to the horizon line. You place things on that wall by drawing lines that flow to the vanishing point. It sounds tough, but it's really quite simple.

Comic-book backgrounds fall into two basic categories: 1) those that are man-made, and 2) those that we find in nature (trees, rocks, sky, landscapes in general). As artists we owe it to our audience to carefully plan and draw all backgrounds. There's often a temptation to spend all of our time drawing the figures, and then "blow off" the backgrounds. Quite often, extra effort spent on backgrounds can change a rather ordinary panel into a much more believable piece of art.

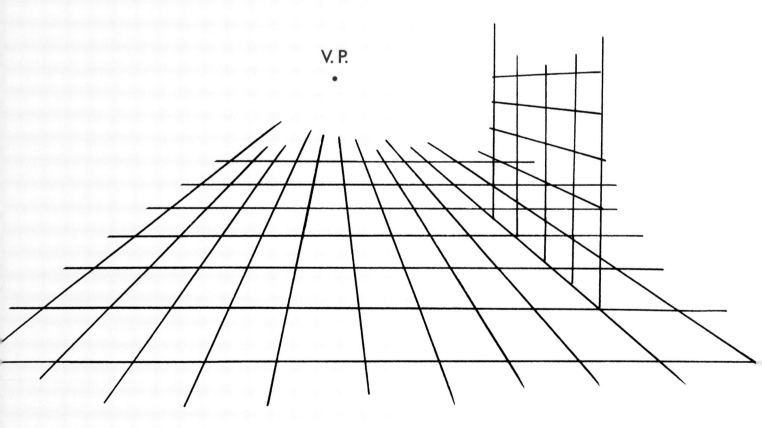

V. P.

FOLIAGE

You're going to have to fill that background space. Let's start with nature.

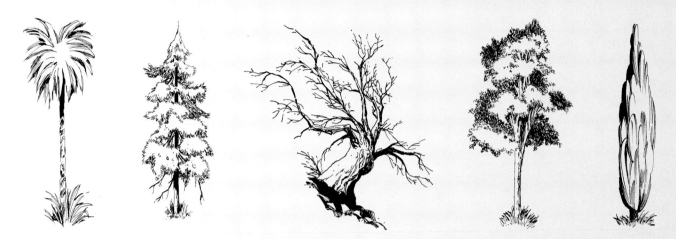

Obviously, you want to get the foliage just right: you don't want to draw palm trees in the Yukon, or evergreens in the tropics. Trees and shrubs come in all sizes and shapes. Varying the size and shape will turn an otherwise boring background into something that can add to the atmosphere of the scene.

A stand of trees becomes quite a different puzzle to solve. You will want to maintain the authenticity of each tree—an elm looks like an elm, and a forest shot full of tightly planted trees is unlikely to show enormous diversity. But you will want to avoid the rubber-stamp look, so take care to establish your light sources.

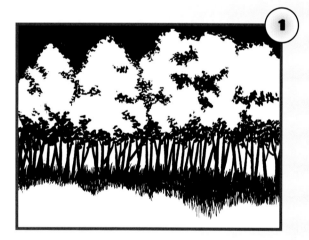

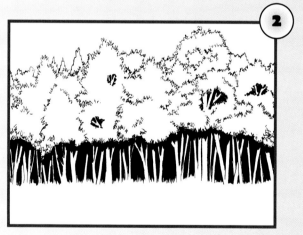

The location and time of year have a lot to do with how we treat backgrounds, and foliage can instantly indicate the season or the weather. A full, lush tree looks quite barren in winter and blowing leaves can indicate autumn.

For a night scene, try showing the trunks dark and leaves light against a dark sky (figure 1). Try the opposite effect for a daylight shot. The spaces between the trunks and branches become dark. The leaves now become linear, but remember to show "holes" in the trees where we see some branches poking through (right portion of figure 2).

BACKGROUNDS AS A STORYTELLING AID

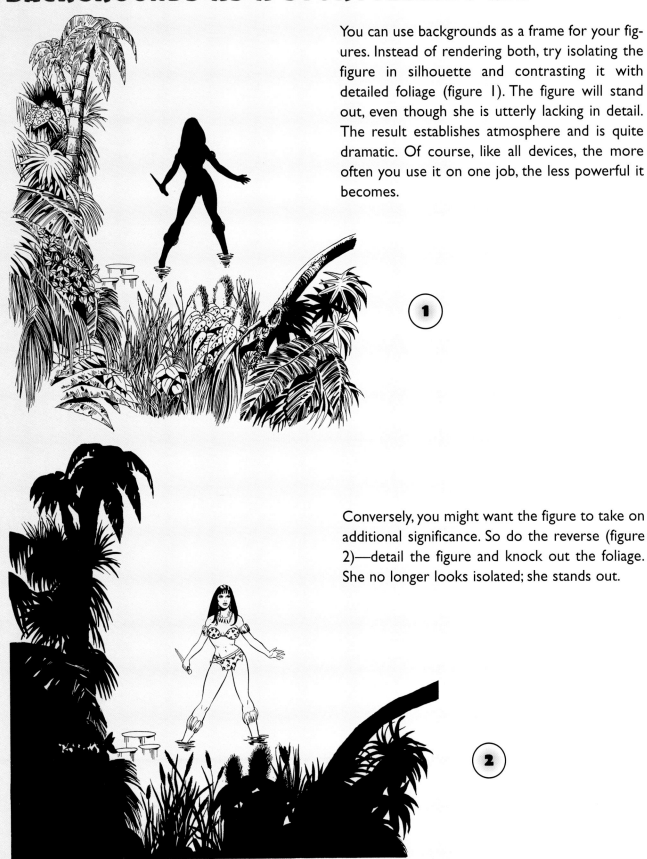

You can use backgrounds as a frame for your figures. Instead of rendering both, try isolating the figure in silhouette and contrasting it with detailed foliage (figure 1). The figure will stand out, even though she is utterly lacking in detail. The result establishes atmosphere and is quite dramatic. Of course, like all devices, the more often you use it on one job, the less powerful it becomes.

Conversely, you might want the figure to take on additional significance. So do the reverse (figure 2)—detail the figure and knock out the foliage. She no longer looks isolated; she stands out.

THE PASSAGE OF TIME

The concept of showing movement through time and space is the key element of graphic storytelling. As our hero moves closer to the "camera" (the reader's eye), we get a feeling of time passage because of the appearance of the snake (opposite page).

A bit of minor foreshadowing in previous shots might be useful so the snake doesn't appear out of nowhere.

Unlike filmmakers, we are condemned to create the illusion of movement instead of physically documenting it. Avoid adding visual elements out of nowhere or using deus ex machina ("a god from a machine")—a storytelling device in which something or someone simply appears for the purpose of cleaning up wayward plotlines.

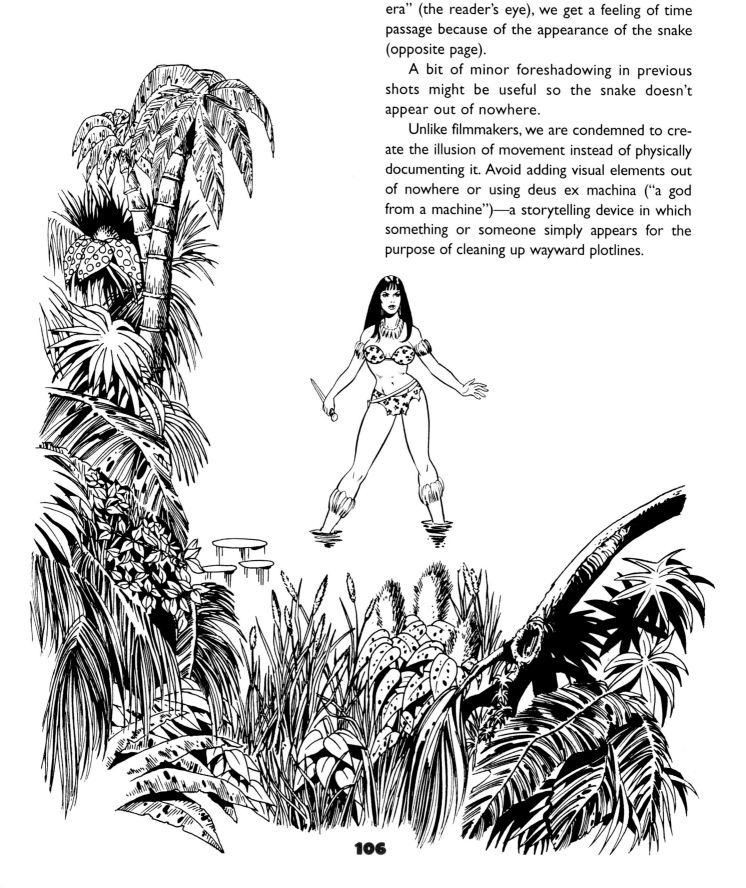

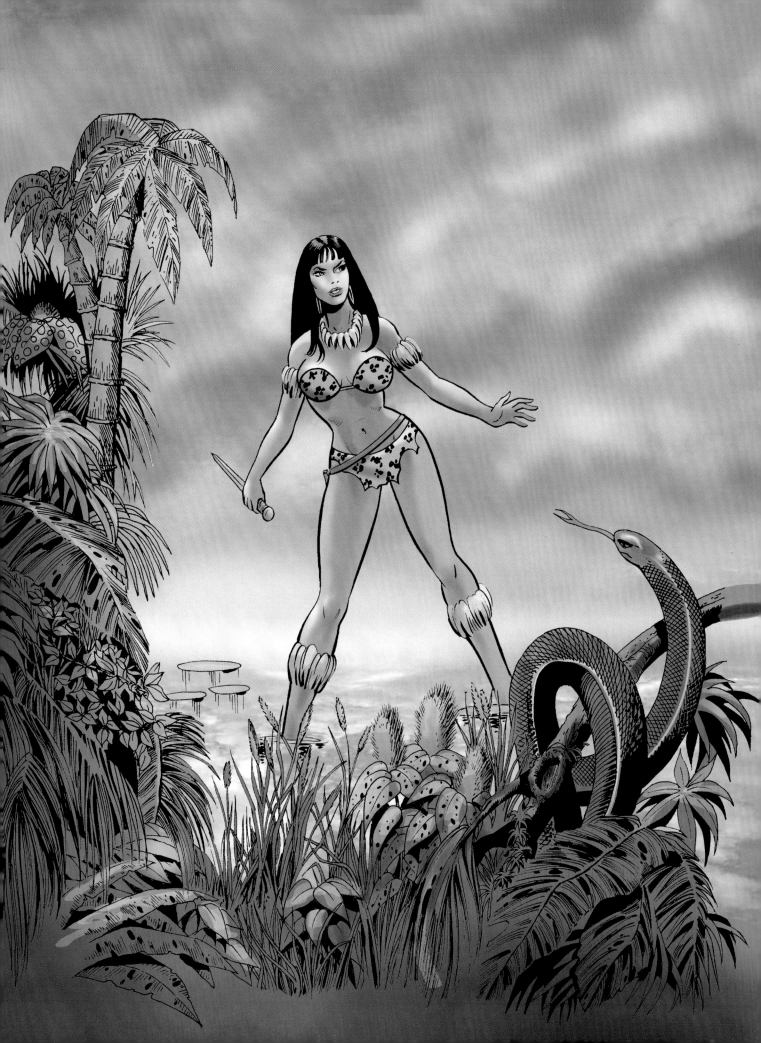

EFFECTIVE SHORTCUTS

When the copy machine first became available to artists, the legendary Stan Drake (*The Heart of Juliet Jones* and *Blondie*) discovered an interesting and timesaving method of using it in his work. Once Stan decided on the content of a piece of panel art, he would make a high-contrast copy of a photo in the approximate size needed. He would then white-out the gray areas and unwanted flotsam, and go back in with a brush or a pen and add figures, cars, foliage, et cetera.

Try to solve most of your composition problems when you take your photos. Then it becomes much easier for you to create the mood as you add your figures and the rest.

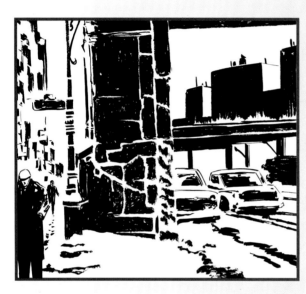
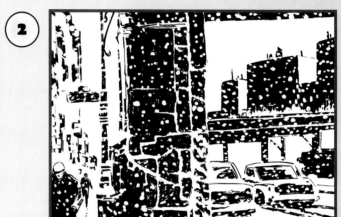

The bleak, stark atmosphere in figure 1 is created by large, black areas with almost no linework. The lonely figure on the left and the car on the right plowing through the snow were added to complete the scene.

Snowflakes were added to figure 2 by stippling white paint all over the art. Be careful not to white out any important black lines.

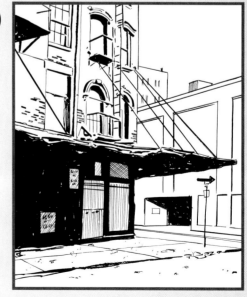

Notice how a lot of the lines in the building have been made to look rough and uneven in keeping with the run-down look of the area (figure 3). It helps to contrast the large, black areas with thin linework. Figures were purposely left out to add to the loneliness of the scene.

BREAKING IN

As a newcomer, you will bring your portfolio around to a bunch of editors and art directors—possibly at their offices, probably at comic-book conventions. Many editors and ADs are nice people, but they stare at a million portfolios every year, and at least 999,750 of them are lousy. Of the remaining 250, maybe 240 show potential, and some editors and ADs will "adopt" a couple wannabes and help them along. The remaining ten have actual talent, although roughly zero of them will be ready to pick up an assignment their first time at bat. Your chances of selling your skills without a track record are quite low.

So, if the editors and ADs say you're almost good enough to get work, ask them if they know anybody who needs an assistant. We guarantee you, every single editor and art director knows a dozen artists who could use a good assistant. Connections can be made, and if your assistance actually helps the editor save a job, said editor will remember you forever.

Most editors and art directors are receptive to polite behavior. Call and make an appointment for a face-to-face meeting. Sending your work in unsolicited condemns it to the slush pile, and the slush pile of unseen artwork is the second-largest mountain in North America. Scope out comics conventions in your area: if an editor is advertised, call the office and arrange for an appointment at the convention.

Your portfolio should include a wide range of representative samples: superheroes are great, but draw some talking scenes and some romantic stuff, too. Draw some cars and buildings. If you ink your own work, bring in copies before they were inked—they will give the editor an idea of both your penciling abilities and your inking abilities.

Most important, make certain you've got several pages of actual storytelling: poster shots only tell people whether or not you know how to draw poster shots.

Never bring in original art—it can get lost or soiled. If you do mail a portfolio (and don't say we didn't warn you), never, ever, ever send original art. It can get lost, but even if it doesn't, it will be lurking in that huge slush pile for decades before you get it back.

Finally, here's the most important bit of advice we can give an artist who's trying to break in: persevere. Be insistent without being obnoxious. Don't give up, have faith in yourself, and listen to advice. If they say you stink, and you truly disagree, do not get discouraged. Every comic-book publisher and newspaper syndicate rejected *Superman*—it only saw the light of day when an editor who had rejected it recommended it to a publisher who was desperately looking for new features for his latest project. Remember, this is show business.

If you're having trouble getting your work seen, take heart in the following fact: It doesn't take long for an editor or art director to flip through an artist's portfolio. If you were a writer, it would take the better part of an hour to get a feel for your potential—and new writers get hired all the time.

So do new artists. You might as well be the next one.

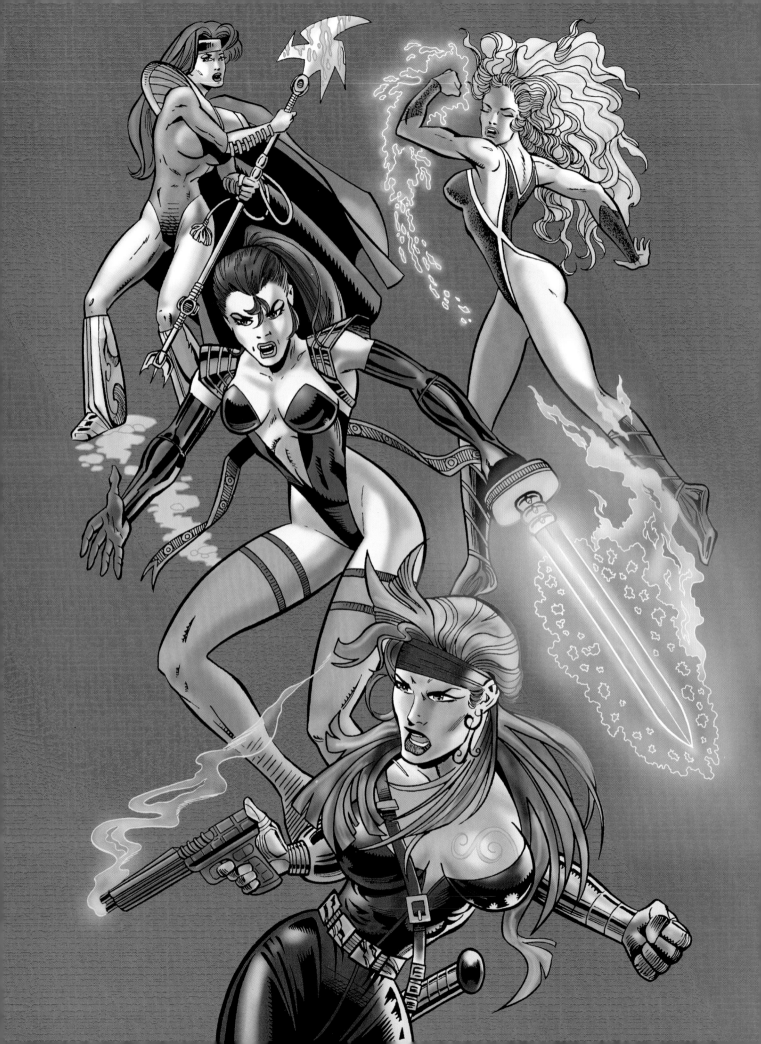

WEAPONS AND POWERS

There's nothing more enticing than a large, impossibly realized woman holding a gun that weighs more than a Volkswagen.

Somehow, in the world of heroic fantasy, people flying around with beams of light coming out of their eyes is unrealistic, but humans holding weapons that look like they have sufficient recoil to knock an elephant through the Taj Mahal is perceived to be "real." Go figure.

So, now that your Bodacious Bad Babe is dressed and coiffured to kill, she needs something with which to kill. (Or, if she's a Good Girl, something to defend herself with.) We've got to give her some weapons.

Realistic weapons require reference work, and there is no limit to the amount of reference material out there. Just about anything is available on the Internet, and there are hundreds of magazines and books that will show you what every imaginable real weapon looks like—if it's a real weapon you're looking for.

GUNS AND AMMO

"Form follows function," the design books say. When designing fantasy weapons you can just forget that rule completely. Some comic-book weapons look gigantic and cumbersome to use, but a quick glance at the comics rack and popular video games indicates that that rule hasn't stopped anybody. However, there is a point past which everything looks absurd—as though you were doing a parody of a contemporary action scene.

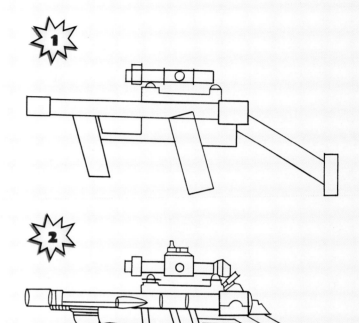

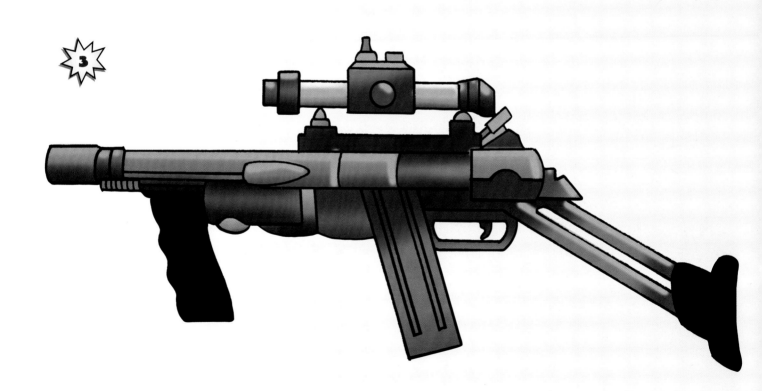

Designing weapons is simply the act of putting together interesting and seemingly appropriate shapes. You can find out what is seemingly appropriate by looking at pictures of the real thing and letting your imagination run wild. Once you've established a reference point, add very simple shapes until you have a basic look that appears functional and interesting, and then slowly add logical details: ersatz gunsights, triggers, magazine chambers, stands, and techno-doohickeys.

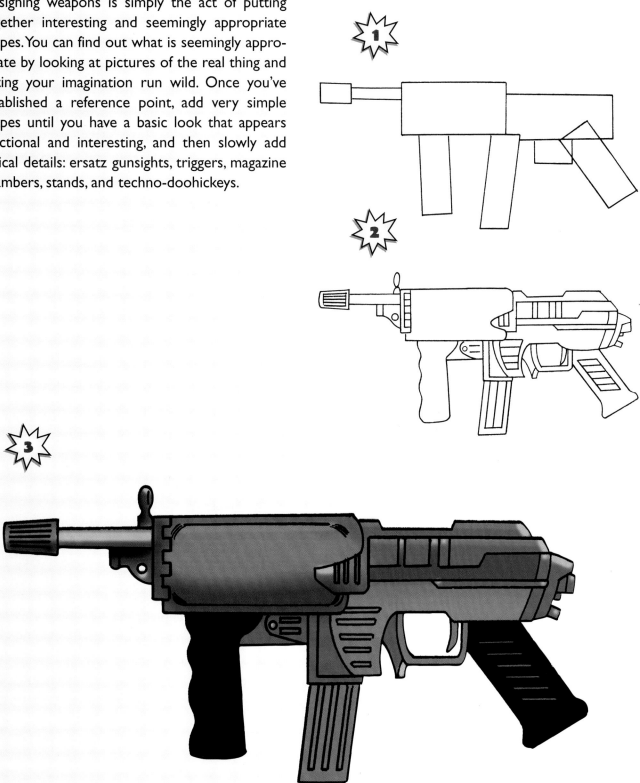

EXOTIC·LOOKING WEAPONS

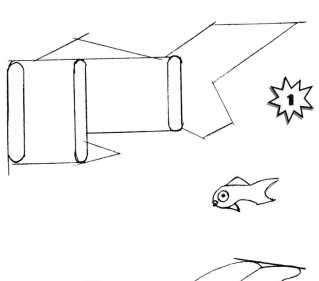

1

Futuristic and science-fiction stories demand the most exotic-looking weapons. From small hand-held pieces to the really imaginative weapons held as rifles, you can really test your imagination. The deadly-looking pistol at left, for example, was inspired by a fish. Don't laugh . . . inspiration can appear anywhere at anytime!

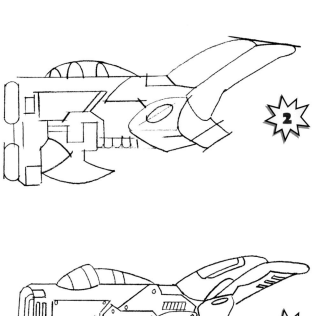

2

1

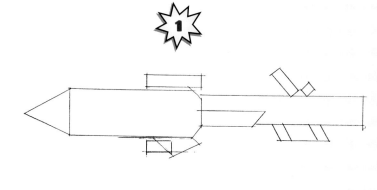

2

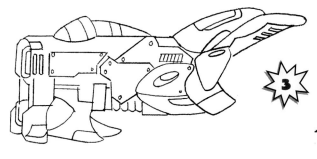

3

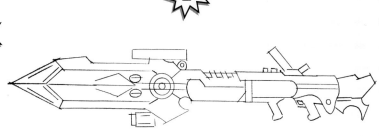

3

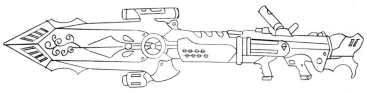

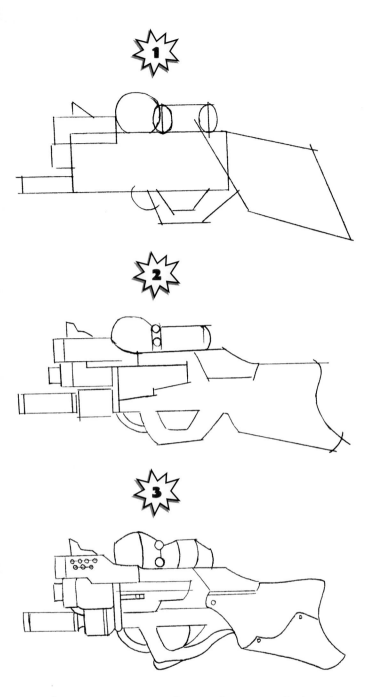

Does it fire grenades or blow bubbles? The look of the weapons you design should reflect their firepower. These frightening sidearms will huff and puff and blow your house down.

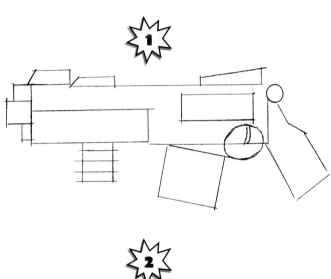

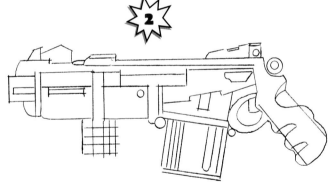

Sometimes you might not be sure which side is up and which side is down on the weapon you've designed. That won't matter if your character looks like she knows how to use it.

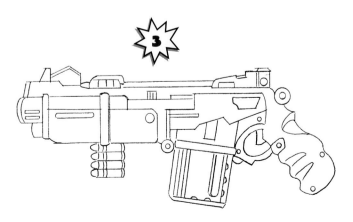

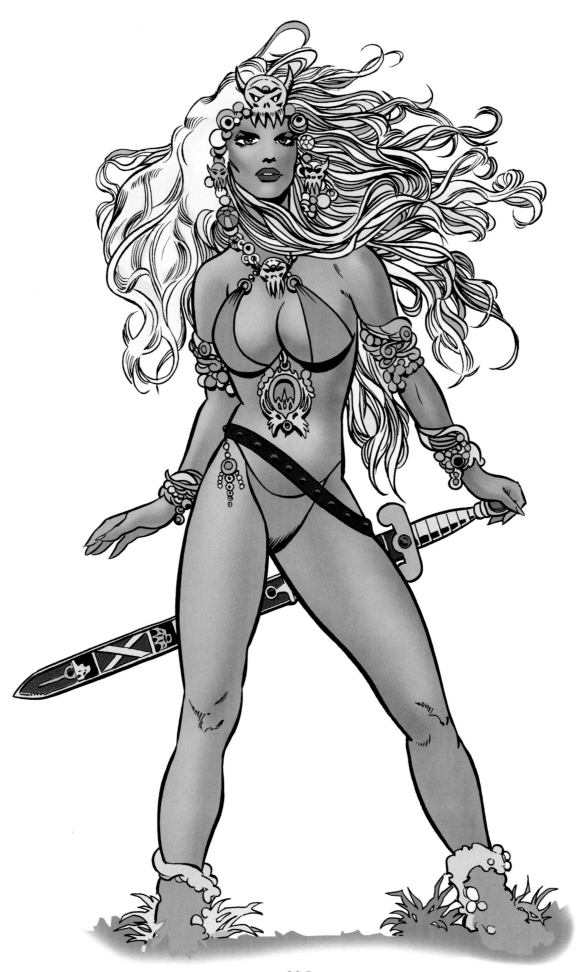

MEDIEVAL WEAPONS

When your hero or villain comes from a specific time in history, or a reality-based, fictional historical period (as in *Conan* or *Xena*), you've got to go back and do some research. It is hard to imagine any artist creating something out of whole cloth that appears as vicious and deadly as the types of weapons real people used before we switched to such sophisticated firecrackers as nuclear missiles and biogenetic bombs.

Start with real battle-axes, swords, shields, maces, and such, but don't be afraid to add your own touches: decorative jewels, runes, skulls, chains, spikes ... the sort of stuff that people might wear to a heavy metal concert.

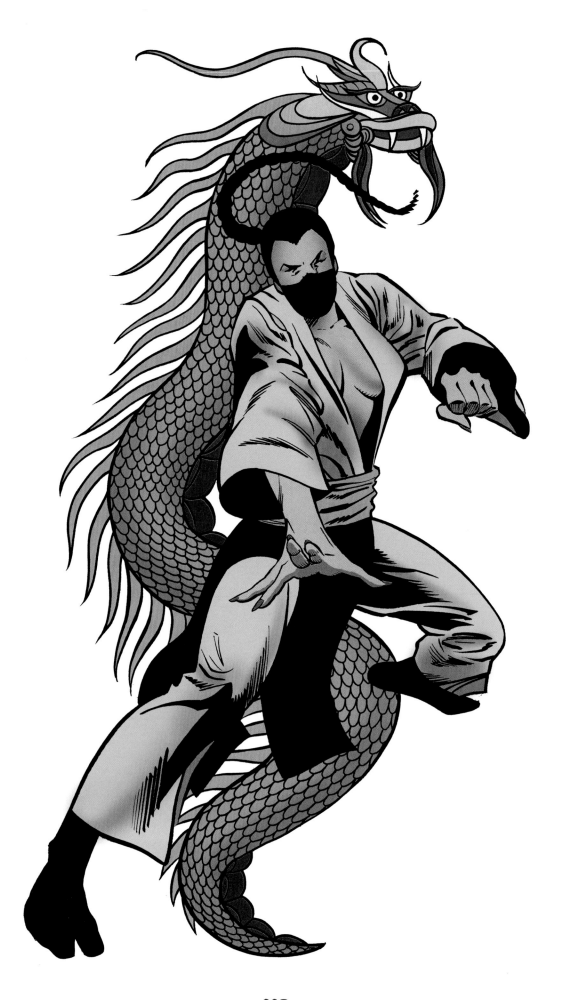

MARTIAL ARTS

Okinawans and Koreans designed whole systems of defense around simple tools because at certain times in history their oppressors strictly forbade the ownership of any weapons whatsoever. Threshing tools, scythes, and handheld metal stars became the weapons of choice. To this day, martial artists from around the world practice their weapon katas daily as part of their ongoing training. Again, add your own little touches to give them a unique look.

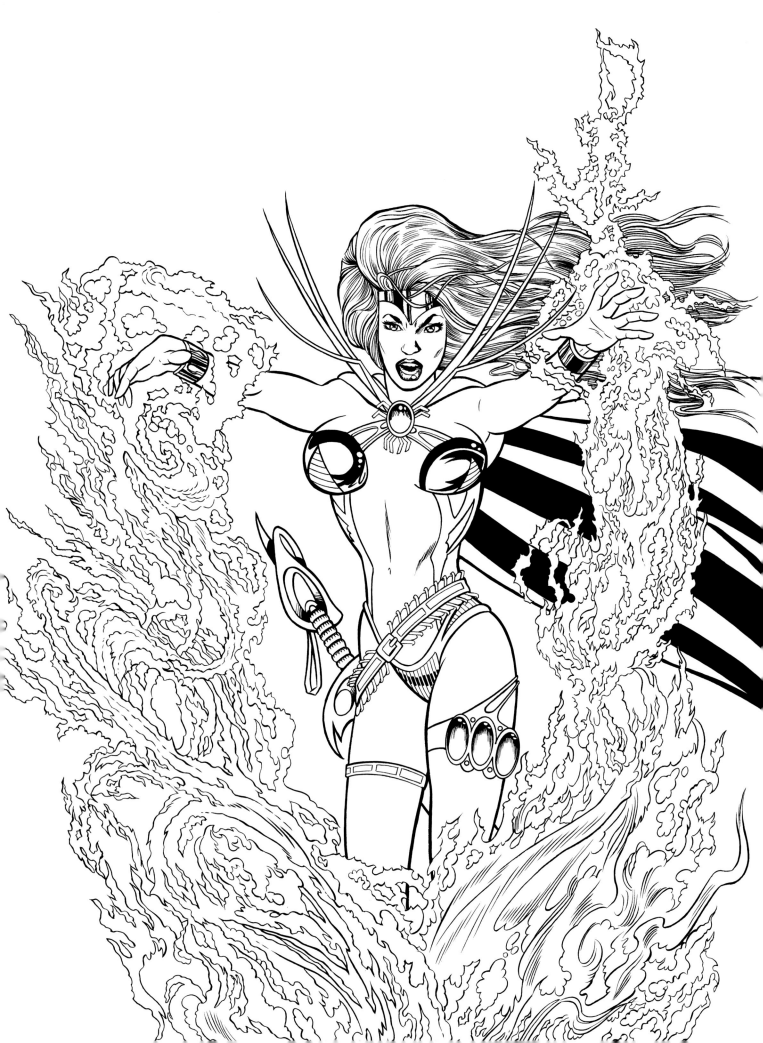

HUES TO DAZZLE

Perhaps the quickest way to color your art is with markers. They're easy to use, they require little clean-up (especially if you think stained fingers are a fashion statement), and there are about a million different colors to choose from. They're also a lot trickier to use than they seem.

No matter what you might use for your actual drawing (brush, pen, or black marker), and no matter what types of paper you use, you should avoid coloring your original art at all costs. On those rare occasions when you might have to color on the originals, you have to be certain of how the markers, ink, and paper will interact.

You won't be able to blend colors very easily on five-ply board because the surface of the board will absorb the color very quickly. When laying in large areas of even color, a flat wash becomes virtually impossible. Instead, use a metal straight edge or metal ruler and run your color marker down alongside it from top to bottom, moving the ruler to the side and repeating until the area is completely covered with vertical lines of color. (It can also be done from bottom to top.) Remember, once you start a line, you've got to finish it or you'll end up with a blob.

Coloring black-and-white art is a lot easier if you work on photocopies or print-outs of high-quality scanned art. Make a few extra copies that you can screw up until you finally get it right.

The kind of color markers you use is critical. There are three different types of color markers. Chemical-based markers pick up the black lines and contaminate not only the art, but the other markers as well. Non-permanent watercolors are, well, non-permanent. Alcohol-based markers are the most useful and flow most evenly: Pantone markers come with three different tips on each marker. The colors also correspond with all Pantone color paper, inks, and computer colors, and their color-coding system is the standard throughout the greater graphics industry.

While we're on the subject of color, we should also consider hue and value (intensity). For example, the color red comes in many different hues such as crimson, vermilion, brick red, and carmine. The value or intensity of that particular hue can vary as well: 100% crimson is quite intense, but it will lose value as you add white. A lot of white will turn crimson into a pale pink. It will still be crimson, but its value will be more in the range of 10%.

Whereas you will work out your own system over time, it's a good idea to begin coloring by laying in the lightest values first. That way you can build up values gradually . . . and this is where things can get tricky.

The bad news is that copier paper can't absorb color very well, it just sits on the paper. It dries very quickly, so you have to move fast when you want to blend colors or create a wash; you're pretty much limited to three coats. After that, your colorwork will turn mottled and muddy. As long as your inks are wet you can blend colors together with a little practice.

To blend two colors, try uncapping both markers at once and, beginning with the lighter value, work very swiftly, laying in color toward the direction of the area to be blended. Quickly put down the darker-value marker and move toward the blend area. Pick up your light marker again and blend both colors by rapidly overlapping.

Keep notes as you experiment. Some darker colors tend to obliterate everything underneath, so start off with the lighter values until you know what to expect.

If you want a slightly darker value than your base coat of color, simply wait for it to dry and cover the area with another coat of the same marker. This works particularly well with pale flesh tones.

Try putting down a coat of pale flesh. Before it dries, take the same marker and go into the areas where the shadows would fall on the neck under the chin. For very dark areas, try another marker of the same hue but with a slightly darker value. Carefully touch up the smallest, darkest areas.

When coloring flat areas, it's easy to lay in a flat wash. All you need is a juicy marker and a piece of copy paper, but be wary of marker seepage.

Start at the top of the area to be colored and work your way down. Move your marker rapidly from side to side, making sure to cover the whole area. Do not return to a colored area or your flat wash won't look even.

Once you feel comfortable with this technique, try it on your black-and-white art—on a copy, of course. With a little practice, you will be able to judge how much your marker will bleed. You should allow a small area between the background wash and the actual art for that bleeding color to seep into.

A graded wash begins at the top of your art as with your darkest value and gradually becomes lighter as you move down the art. Begin by laying in a flat wash very quickly over the whole area.

Go back up to the top and begin to put on a second coat, working your way down. You'll see a soft blending take place. If you allow the base coat to dry before you begin the second coat, you will wind up with some unwanted hard edges. Experiment using a different color marker for the second coat and you'll most likely surprise yourself with some wonderful effects.

It's usually dangerous to apply a third coat of color. At this point, if you want to darken an area, try turning your paper over and work on the reverse side. Although the first side may be fully saturated with color, the reverse may still be dry enough to absorb one coat of color. Copy paper will let the color show through, thus deepening the value on the front.

Sometimes, no matter how much you try to avoid it, you will have to color the original black-and-white art directly on the original. Lightly draw with a soft pencil. Ink the art, then make certain you've made a couple of safety copies. Be sure to let the drawing dry completely before you erase the pencil lines. Now you can safely color your art with Pantone color markers.

From time to time you will probably screw up. That's okay—there is one way to fix the problem that is almost impossible to detect.

Get yourself a sharp X-Acto knife and a safe surface to cut on—dining-room tables and antiques should be avoided as a new X-Acto blade is extremely sharp and will cut through everything. Try an artist's cutting board.

For the sake of convenience, let's say your error is in a simple square area outlined in black. Slip a clean piece of copy paper under your art and masking tape to hold the paper down.

Carefully cut the unwanted area away, thus leaving a square hole in your art and a perfectly fitting square underneath. Take another plain piece of paper or board and mount your art on

it. Color the new square and mount it in the open hole. It should fit perfectly.

We prefer to mount artwork using rubber cement rather than spray mount, but both glues create problems. Rubber cement eventually stains the art. For that matter, marker color tends to change colors when exposed to sunlight over time. If you get rubber cement on a colored area, it will turn a bit lighter when you rub it off. Spray mount tends to get all over the board. You might want to use tweezers to hold or move your art around before mounting.

Take all precautions to keep your art clean and neat, it's part of what makes you a professional.

Before you can declare yourself done, there are some little finishing touches that deserve consideration. Colored pencils can be used very effectively once all your marker work is complete and dry. Applying pencils over markers is a one-way street: You can't paint over colored pencils with markers, so analyze your work carefully before you reach for the colored pencils. White pencilwork can soften blends. Lightly rub the area and build it to the desired value. You can spot dab very small areas with white paint (Pro-White) and use a fine-point sable brush for things like small highlights in the eyes or a small sparkle on the edge of a highly reflective surface.

Let's try a little exercise. We're going to color this book's cover. The black-and-white art appears on page 120. Remember, before you attack the problem, make some copies. We'll remind you of the rules:

- Slip a sheet of copy paper under the art so you don't mess up your drawing board.
- Get the markers you need, and some Pro-White.
- Get some colored pencils—at least get a white pencil.
- Get yourself a sharp X-Acto knife.
- Procure a safe cutting surface.
- Have some blank sheets of copy paper on hand.

COLORING YOUR BABE

The numbers refer to Pantone color numbers. These are the same Pantone numbers you'll find on their markers and on the Pantone computer colors used in most popular graphics programs.

Begin with the figure, using #1205 on copy paper. Don't scrub, there are more colors going on top.

Lay in one coat only. Use #148 on the darker flesh areas and immediately coat it with #157 while the area is still wet.

Again, don't scrub.

You can use #493 for the lip color and #317 for the eyes. Make substitutions if you wish.

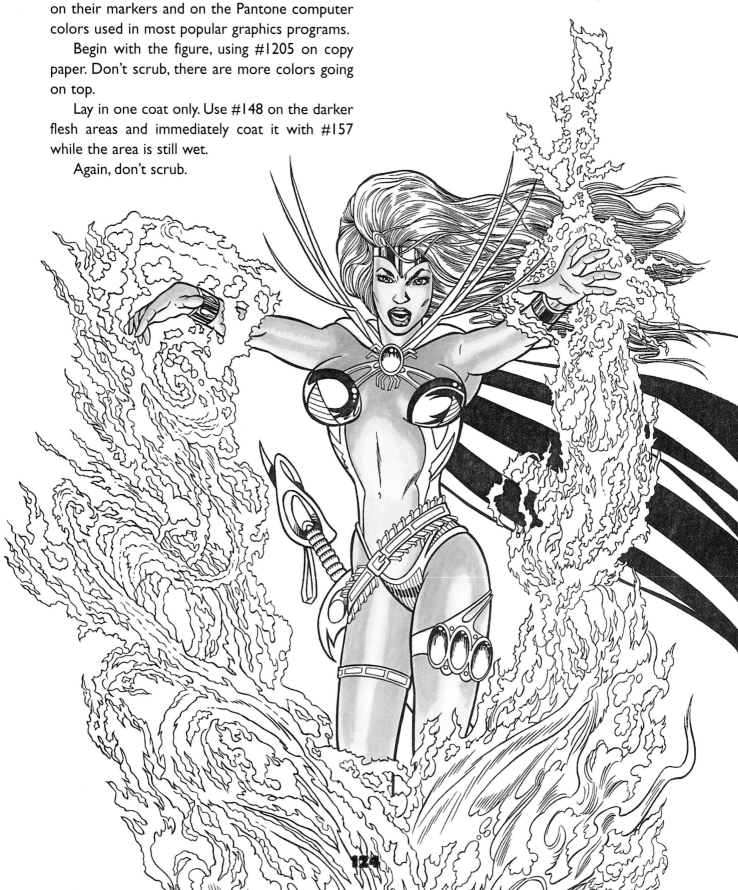

Color the fire with a single coat of #100. Remember that it's usually a good idea to begin with your lightest values and work toward the darker ones.

Where you want the flames to be darker, use #115. Now use #115 on the gold parts of her costume as well.

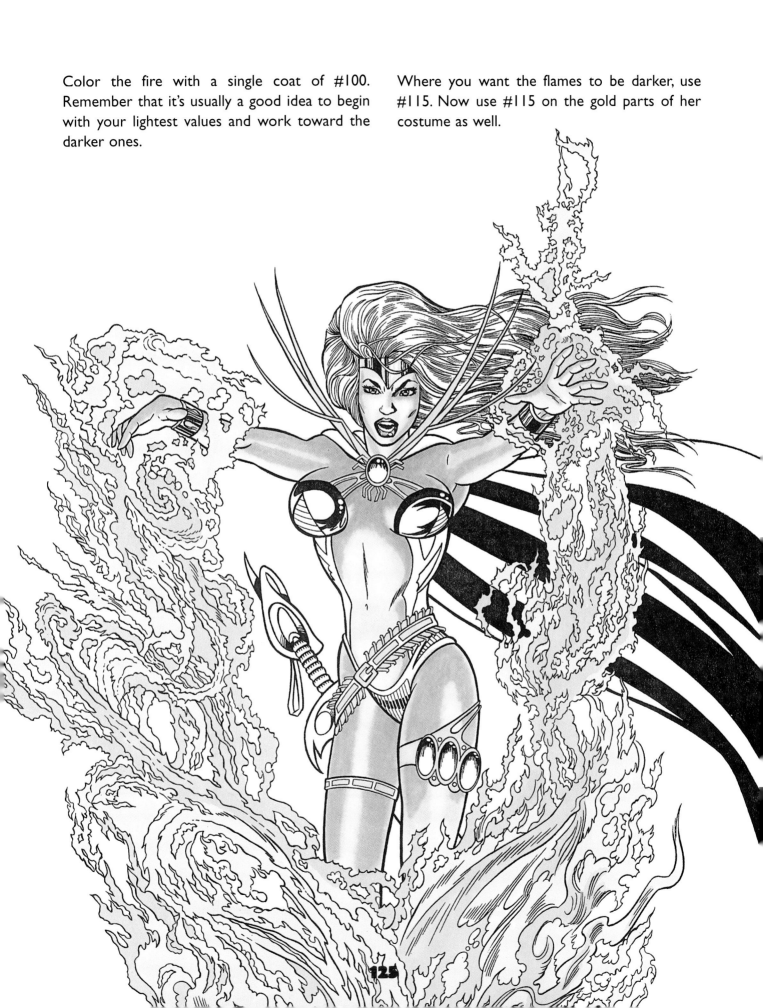

As you work with colors darker in value, pick out some areas of flame using #151. Now use a dark warm red where indicated.

The colors for the cape are cool grays (#5 and #7), #151, and warm red. The underside of the cape can be coated with either of the gray colors; once it is dry, apply a warm red over it. For the upper side of the cape, apply a base coat of #151 and work the warm red over it while it's still wet. Hair colors are cool gray #5 and #100. Use them sparingly. Costume and jewelry are #151 and #115, and the sword handle is #100.

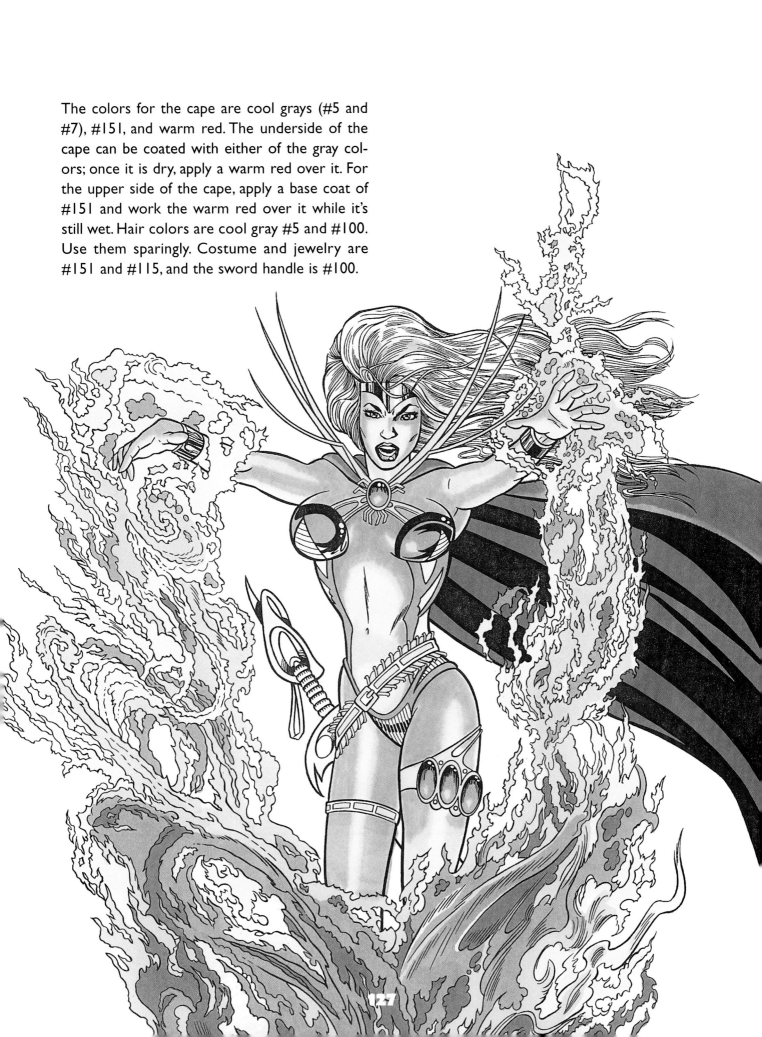

Here, use warm red for the costume and jewelry, and use #471 for the leather parts of the sword. Use a white Prismacolor pencil to hit highlights—wait until all the marker colors are dry and don't try to use a marker over the pencils. Now, compare your work to Mark's colors on this book's cover. There are a lot of ways to approach this problem, but we think Mark's solution was fantastic. How does yours stack up?

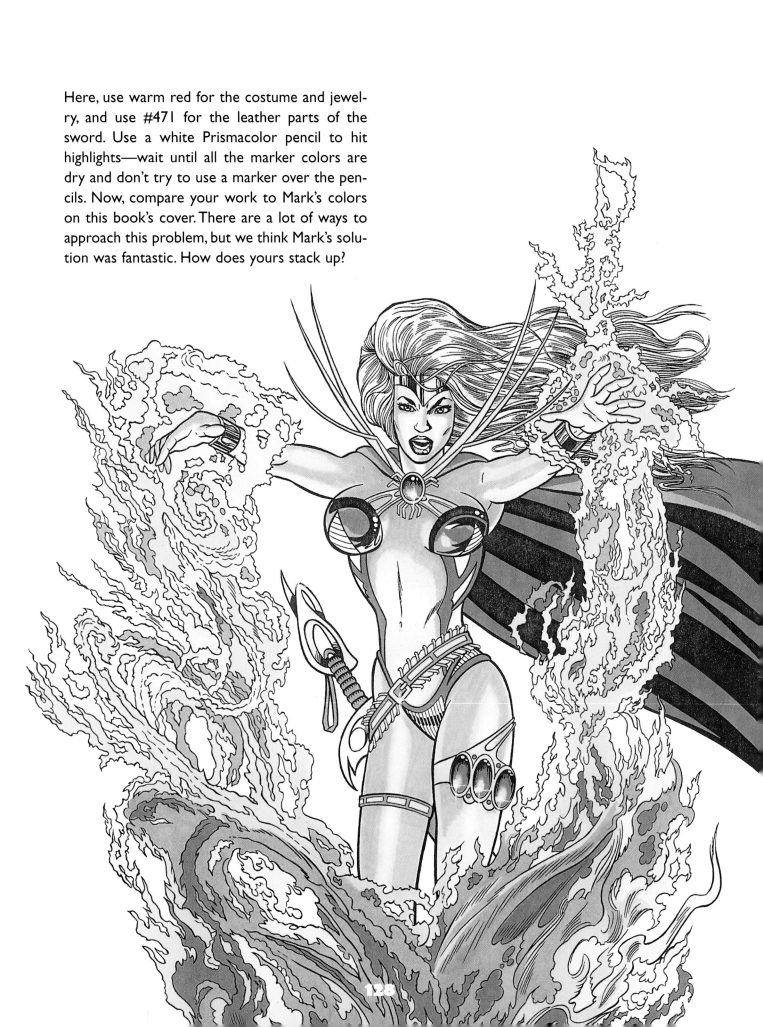

COLORED PENCILS VERSUS MARKERS

You might want to render your art with colored pencils rather than markers. Artist George Sellas has rendered his superheroine (figure 1) in pencils, but the procedure is quite different than when rendering with markers. Because pencils tend to create a waxy buildup, they should be applied with the lightest of touch. Patiently apply one light coat of color over the previous coats to slowly build up, and carefully blend as you go along. With a little practice you can master this technique.

Figure 2 was rendered with markers, with some lightly applied white pencil to soften the edges of color as they near the highlighted area. A touch of white paint is then applied to the center of the highlight with a fine brush. The clearest example of this can be seen in the highlights of her hair and shoulders. Both illustrations were done on a black-and-white Xerox copy of the original art.

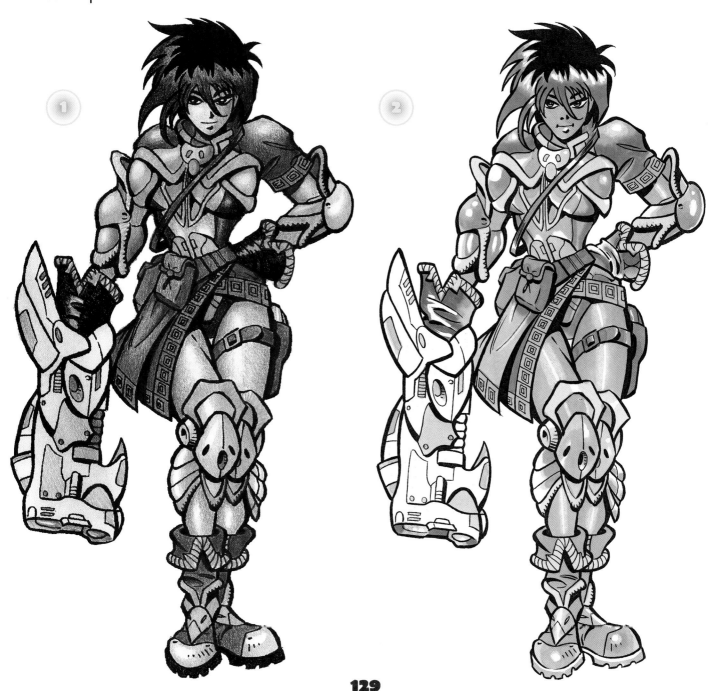

COMPUTERS—HAMMERS OF THE GODS

Let's start off with a crucial piece of existential philosophy: The computer will not create art for you. It will not draw. It will not think. It will not make your life better on its own. The computer is a tool—an important, extraordinarily powerful, and ever-expanding tool. But like any other piece of equipment, you've got to make it do what you want it to do.

Why would you want to use a computer to make art? Well, first and foremost, it can look cool. Making your artwork look cool is a good thing. It arrests the eye and allows you to bring attention to specific aspects of your art. It creates perspective and dimension. It can heighten or soften impact. It allows for greater differentiation between the elements within your design. It creates the illusion that you are gainfully employed.

There are a few limitations on the use of the computer as an artist's tool: time, technology, and money. It is quite possible to spend hours and hours playing with all of the potential special effects and never complete your work.

You'll need the right software and the right hardware. We'll get to this anon, but the limits on technology are determined by the amount of money you can spend and the amount of time that you have to learn the software.

When properly used, your computer can generate all kinds of special effects. It can save you a lot of time—but only when compared to the "way things used to be."

THE ULTIMATE TOOL

Depending upon your software and your imagination, you can do just about anything to your digitized art. You can stretch it in any direction or combination of directions. You can drop it back into perspective. You can enlarge it, reduce it, or turn it into a 3-D object, and then chop it up into little pieces and rearrange it.

You can select certain elements and duplicate them, pasting wherever you desire. You can enlarge the art on the screen—1600% is a typical high-end—and make infinitesimally small corrections: You can narrow the bridge of a nose and remove a dozen pixels from an oddly shaped nostril, giving your fantasy lady the perfect rhinoplasty.

You can "flop" the image—what was left-to-right is now right-to-left. You can "invert" the image. On a black-and-white piece of art, to "invert" means that what was black is now white,

and what was white is now black. It's a lot more complicated in color, but the concept is the same. Red becomes half green and half blue; green becomes half red and half blue; blue becomes half red and half blue; yellow becomes blue ... and so on. You'll see examples on the following pages.

COLOR MADE EASY

We discussed red-green-blue, also known as RGB. There are a number of different color systems available to you—CMYK is at least as popular as RGB. CMYK stands for "cyan-magenta-yellow-black," which is useful if you're trying to speak a common language with your printer.

The RGB system is based upon the three colors of light and is useful for a beginner who is more familiar with red, green, and blue than cyan and magenta. 100% red plus 100% blue plus 100% green equals white—therefore white is the combination of all colors; 0% red plus 0% blue plus 0% green equals black; therefore black, as we all know, is the complete absence of color.

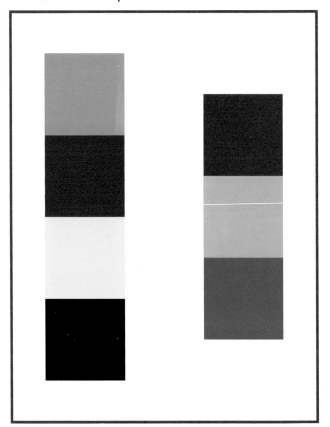

The CMYK (left) and RGB color systems

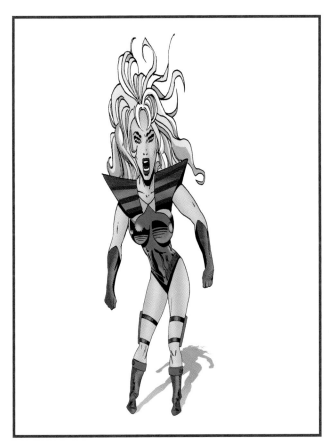

Looks like this bad babe made a trip to the fun house.

Of course, that isn't a problem if you're drawing for use on the Internet. But if your work is going to appear in print, you are going to have to take the printing process, and the paper, into consideration.

Your software can add tones—shades of gray—the same way it adds color. You can select any shade of gray, generally in 1% increments. Tones are made up of uniformly placed tiny dots or thin lines; you can also add textures and patterns—crisscrossed lines or pebble patterns or about a million other types of fills. You can turn any of your lines (or portions thereof) into tones of gray or color.

Many graphics programs include some sort of airbrush tool. If you've ever worked with a real airbrush, you know the computer airbrush does not give you the type of smooth appearance the real tool provides, although it is fine for most uses—particularly if your art is going to wind up on-screen anyway.

You can also add gradients—tones or colors that subtly shift from one shade to another. Let's say you have your character dropping down a mine shaft, and you want to create the illusion of depth. The top of the shaft would be lighter than the bottom, so you choose a gradient that runs from a 10% gray at the top, to a 60% gray at the bottom. Voilà! Instant depth. It works in color the same way.

Gradients need not be linear: you can do circular gradients—useful for atomic-bomb explosions—or zigzag effects, or just about whatever you can think of.

You can sharpen your image or any portion thereof. You can trace the edges, opening up a dark image for color. You can automatically replace colors or tones.

You can use any of several thousand special effects. Your software allows for certain built-in special effects; the better software allows for the addition of "plug-ins" ("filters"), which expand your effects repertoire all the way up to the very limits of your budget. You can't possibly have too many special-effects plug-ins, although you might not want to keep all of them installed at any one time in the interest of space.

And then there's coloring. We've talked about how you can add color or tones to portions of your art—you can add color to the whole thing as well. In the comic-book industry, coloring is a special storytelling skill, and great color artists are few and far between. Color must do more than look good and be accurate—it must direct the reader's eye through the story, highlighting elements that need to be brought to the forefront, keeping subtle elements visible but subdued, and aiding the emotional climate of each scene.

Computer monitors are extremely luminescent, and therefore make colors look more vibrant. The same exact color—defined as the same percentage of each of its component colors—will look quite different on various grades and coatings of paper, and they are unlikely to look as vibrant in print as they do on the screen.

To sum up, your computer is an incredibly powerful tool that can allow you to dream and conceive your art in new and innovative ways.

WHAT SHOULD I BUY?

The question boils down to, "Should I buy a Windows machine or a Macintosh?" Forget about how the Mac dominates the graphics industry, and forget about how Windows dominates the business world. There are simple questions that will make your decision easier.

Consideration One—The benefits of Windows.

1) Roughly 90 percent of the computers out there run or can run Windows. This percentage includes all Power Macintoshes, which can run Windows as well.
2) The purchase price of Windows machines is a bit lower. This is why roughly 90 percent of all computers run Windows.
3) There is a wider selection of general software available for Windows. When it comes to commercial programs, there isn't a significantly wider range of functions, but there are more manufacturers within most categories.
4) There are lots more games available for Windows-based operating systems.

Consideration Two—The benefits of the Macintosh. (Note: We're talking about the Power Macintosh.)

1) At the high end of each format, Power Macs are faster than Windows. This is important when it comes to graphics, as graphics processing takes a lot of time.
2) Macs are easier to set up and easier to learn. Mac software is easier to use.
3) The price of maintaining your Mac is lower than a Windows machine—you rarely need to hire a consultant, even if you're a high-tech moron. This is why most artists own Macs. If you add the amount of time it takes to maintain your computer system (such as installing or replacing peripherals), and the amount of time and money you might spend learning how to use the machine, the Mac is far less expensive.
4) Whereas all of the most popular graphics programs are available in both Windows and Macintosh versions, there is a somewhat wider variety of "plug-ins" available for Mac software. This is due to the fact that the Mac was designed for graphics and Windows is simply a patch onto the ancient, text-based MS-DOS operating system.
5) You can run Windows programs on a Mac. You can't run Mac programs on Windows. The inexpensive emulation software (about $50, plus the cost of Windows) slows down the Windows software somewhat, although if you have a fast Mac you might not notice.
6) There are far, far fewer Macintosh viruses out there waiting to get you. Indeed, there were more Windows viruses reported in the first six months of 1998 than Mac

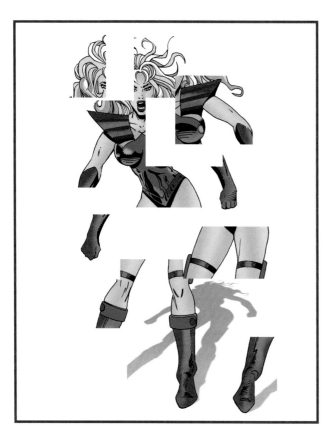

Those bad babes can be really "puzzling" sometimes.

viruses reported during its first fifteen years of existence. However, be certain you buy and use virus-protection software, no matter what operating system you employ.

Consideration Three—Will Microsoft be broken up? Will Apple stay in business?

In the long run, we won't be using Windows or the Macintosh operating systems as we presently understand them. Technology marches on, and even Bill Gates won't be able to stop it. Eventually one of several better ideas will take over.

Computer speed is an important consideration for the artist. Opening huge graphics packages takes time—Adobe PhotoShop runs about 10 megabytes; the basic plug-ins will run another 20. The rule of thumb is this: The faster the machine, the faster you can work.

Processing all of those special effects takes time. Repainting the screen every time you make a change takes time. Time is money; and you don't want to sit around and wait whenever you make a minor change to the appearance of your artwork. You want to see it on-screen the way it will look in print or on the Internet, and you want it on-screen within your lifetime.

The speed of a computer is determined by a variety of factors. It's easy to discover the speed of the operating chip, as that is usually advertised. But there are other critical factors: the amount and placement of cache memory, the amount of memory dedicated to the video end of your system, and such things as how fast data is moved within the machine.

Your CPU (Central Processing Unit) must have inputs for the peripherals you will need. This used to be a problem, but it's rapidly going away. There are a number of different systems for connecting things to your machine—the old, thick-cabled, tough-to-figure-out SCSI chain operation is giving way to the easier-to-connect, cross-platform Universal Serial Bus (USB).

Which brings us to the final CPU consideration: obsolescence. How do you know there

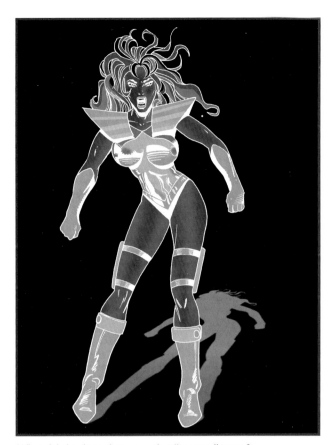

What did she do to deserve such a "negative" image?

won't be something better a few months down the pike?

Answer: Don't worry about it. There will always be something better a few months down the pike. If you're waiting for things to settle down before you buy a computer, throw in the towel and buy a box of pencils.

PUTTING IN

Now that we've completely confused you on the CPU front, we'll move on to the things that you'll need to plug into your computer. There are two categories of stuff: input and output. "Input" is what you put into the machine; "output" refers to outtake, or what you take out of the machine.

You need a variety of methods for putting data into your machine. Let's start with a keyboard. You need a keyboard. It'll help if you know how to type—but you're an artist, so don't worry about that. Keyboards tend to wear out faster than just about anything else you can

135

connect to your computer, so get what you need and don't spend more than you have to.

When you're not tapping on the keyboard, you're probably poking around on the mouse. Or the trackball. Or the trackpad. All these objects do the same thing: they make the screen's cursor dance to your tune.

There's a neat little optional device called a "digital graphic tablet." It's sort of an Etch-A-Sketch™ with a pen. It allows you to "draw" on the tablet and see your creation up on the screen. You can trace objects, design things, or just doodle. Whatever the pen draws on the tablet can be saved in most graphics programs, and can be manipulated like any other art file. This shouldn't be a high-priority item, and quite frankly, you will get better-quality work by drawing in pencil and ink and scanning it in.

Next, you'll need a scanner. Good ones are kind of expensive (at least half the cost of the CPU) and they take up a lot of desk space. An artist needs a flatbed scanner, as much reference material is to be found in books; you shouldn't rip pages out of other people's books just so you can feed them through those fax machine–like scanners. You'll need a color scanner, even if you really think you're going to spend the rest of your life working in black-and-white.

Size is important: bigger flatbeds allow you to scan bigger images without doing it in sections and patching it together (that's called "tiling"). Unfortunately, big flatbeds are exceptionally expensive. Try to make certain your scanner can handle a legal-size (8½" x 14") image.

There's another size to consider: resolution. The greater the resolution, the better the image. 600 dots per inch (dpi) is great for most uses, even though most professional magazine and book printers use resolutions more than four times that precise. Internet graphics tend to be extremely low resolution—as small as 72 dpi—but as access speeds increase, so will the minimal resolutions. Often, simple line art will look perfectly great at 150 dpi.

You might want to consider picking up a digital camera. These things allow you to take pictures and import them directly into your computer, where you can mess with them to your heart's content. Again, higher resolutions are better—and more expensive. A fully equipped computer graphics system will include a digital camera with a resolution of at least 640 x 480 dpi.

Chances are, your CPU will come with an internal CD-ROM player. This is useful because software comes on CD-ROM these days, as do massive amounts of clip art, public-domain photos, and fonts. It will also allow you to play audio discs and CD-ROM–based video games that are compatible with your operating system.

But if you do not have a CD-ROM player, you might want to consider buying a DVD-ROM unit instead. DVDs are high-density CDs; they've been on the market since 1997, initially as a means of playing extremely high-quality movies on your television set. But DVD is simply a form of the traditional CD with many times more storage

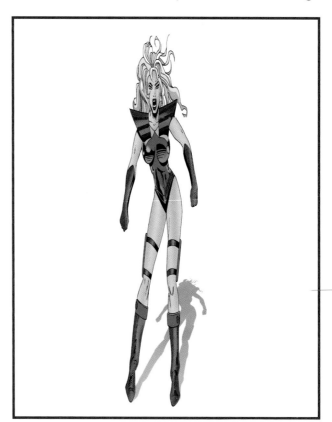

Look out WNBA, here she comes!

space, and the computer industry already has been releasing software on DVD-ROM discs. This trend will continue.

A good DVD-ROM drive will play all CD-ROM discs, as well as audio CDs and movie DVDs. Windows '98 will handle DVD-ROM; Windows '95 will not. Mac OS 8.1, OS 9, and OS X will handle DVD-ROM; Mac OS 8 will not. Upgrades from OS 8 to 8.1 are available free of charge from Apple's Web site, and OS 9 costs less than $100. Both OS X and the next overhaul of Windows will cost more.

Finally, you will need a modem and an Internet service provider. At this moment, we're at the brink of a major revolution—much, much faster access speeds are obtainable through cable television or satellite services and it will be just a matter of time before your system offers something that will make your life easier. High-speed Internet connections are available through most telephone companies.

The least expensive way to get into the Internet is through a computer modem and an account with a dial-up service, such as America Online. The modem can be built into your computer or it can be an external peripheral. The faster the modem, the less time you'll waste watching the screen come together every time you go to a new Web page. Do not buy a modem that is slower than 56K (which, in reality, has a 57,600 baud rate), and 56K is pretty fast for most uses. It might slow down during high-volume periods—but that can be true of high-speed access as well.

Picking a provider can be tough. You should be able to get unlimited Internet service for about $20 to $25 a month, and you should find a provider with a local access number so you don't have to pay the phone company a toll charge.

Why the Internet? Well, you'll need it for business: e-mail is vital, and you can send digitized art files to publishers, cohorts, and friends with ease. The Internet can also be the fastest way to get reference material. Besides, sooner or later you'll

Which way to go? A flopped image.

probably be doing Web-site graphics, and it's important to know what other people are doing, what works, and what sucks—much like life.

TAKING OUT

So much for input. Now let's talk about getting stuff out of your machine.

First, there's the Internet. We just spent several paragraphs talking about it—don't tell us you forgot already. E-mail rules, and that's that.

Next, there's storage media. Your CPU will probably have a built-in hard disk, so let's start there. Again, bigger is better. Graphics files are real big, graphics programs are real big, and operating systems are real big. Real big hard disks are really inexpensive. Do not even think about a hard disk that is smaller than 2 gigabytes.

There are two other storage-media considerations. You have to back up your files. They can become corrupted—not necessarily in the moral sense, but in the "Gee, why can't I open this file any longer?" sense. When your hard disk crashes, your backup becomes your only copy. CPUs develop problems (usually in their power supplies) that may require your bringing the computer in for repair—in these situations, you'll need to work off of your backup discs until you get your machine back.

The computer artist is indeed lucky that the floppy disk is on the way out. Just about everything except standard graphicsless word-process-

137

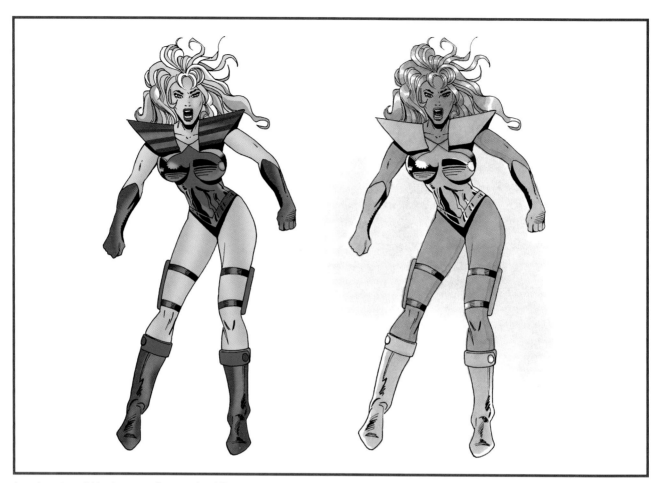

Long-lost sisters? No, these two illustrate the difference between computer (left) and hand-colored art.

ing files require more than 1.4 megs. The bad news is, there hasn't been an established alternative storage standard, although Iomega's Zip Drive has come extremely close. The Zip Drive uses Zip disks, and Zip disks store 100 or 250 megabytes of data, which is an extremely convenient size. Zip disks cost about $12 a piece in quantity.

There is a useful interim device out there called the Superdrive. It will run its own high-storage disk as well as traditional 1.4 meg floppies. However, since those floppies are headed toward the obsolescence of the low-density 3.5", the 5¼", and the old 8" floppies, in the long run this won't be much of a consideration—certainly, not enough to overcome Zip's wide lead.

The price of recordable CD-ROM drives have dropped to less than $400; these are useful for archiving your files and providing your publisher as much as 650 megabytes of stuff on one $2 disc. You can make your own custom audio CDs as well. There are rerecordable CD-ROM drives; they cost about $700, but the disks run more than $10 apiece. That's cheap when compared to Zip disks, but they're more unwieldy to use and maintain.

There are a lot of other types of drives out there, but we'll bet you'll find the Zip disk to be compatible with the greatest number of people. Eventually, your Internet provider will make online data storage available and, whereas it will take a while before people trust such services, they will have another storage alternative to consider.

Finally, you need a printer. There are two types of printers available for the graphic artist: the lower-cost, lower-quality ink-jet, and the higher cost, higher-quality laser printer.

Both come in a variety of sizes and resolutions. You can find printers that will handle

8¹/2"x14" paper, 11"x17" paper, banner paper (up to 44" long), photo paper, and even iron-transfer paper, in case you want to knock off a few T-shirts.

Cost notwithstanding, there are a few significant differences between ink-jet and laser printers. Both come in fairly high-resolution configurations, although laser printers can deliver 2400 dots per inch, which nears magazine quality. Laser printers will deliver dots that are rounder, firmer, and more precise—your art will look better.

The purpose of a home printer is to let your client or collaborators to know what your work looks like, and for these purposes most high-end ink-jets do a terrific job. Printing magazines and slick books is not the purpose of a home printer. If you're running an ad agency or a design studio, save up for a color laser printer—otherwise, give ink-jets a good hard look.

Laser printers have the PostScript graphics programming language built in; most ink-jets need to have it added. Most of the better software packages work in PostScript, so as an artist you'll need

Back at the fun house again

it either way. Most laser printers come with all the necessary ports for connection to a network—Ethernet, LocalTalk, USB lines, and serial ports. Many ink-jets need to be equipped for networking.

Still, adding network capabilities and PostScript will add $250 to $500 to the price of a high-end ink-jet printer, depending upon the size and speed of your network. There are terrific ink-jets out there for around $400. Combined, that's less than half the cost of a black-and-white laser printer. A color laser printer runs $3,500 or more.

Personally, we use a black-and-white laser printer when we need high-quality black-and-white printing and a top ink-jet when we need color or photo printing, using special photo paper for the latter. If we were to need high-end color laser printing, we'd take our file to a service bureau—but for us, that hasn't happened yet.

For the record, old-fashioned dot-matrix printers are virtually useless for the graphics artist.

THE REAL MONEY

Thus far, we have spent between $3,500 and $4,000 of your money, give or take a yard, and not including the price of this book. That's really quite inexpensive for a nearly fully equipped computer graphics studio. However, all of that hardware is completely useless without the software that actually helps you produce the stuff.

So now we get to spend some real money.

Graphics programs are huge, fast, powerful, and expensive. All of the special effects we discussed above (and hundreds, if not thousands, more) can be done in Adobe PhotoShop, which is the most popular graphics manipulation program by far. It's also one of the most expensive—it runs just under $600. Without it, you're nothing. Corel makes a graphics manipulation program called Corel Photo-Paint; although it retails for several hundred dollars less, in this case you're not getting what you're not paying for.

The focus of this book is on producing art in pencil and ink, but you can produce art on the computer itself. It's a whole 'nother world, but

the concepts we have discussed are fully applicable. Adobe Illustrator, Macromedia Freehand, and CorelDRAW are among the most popular of the breed; they run between about $350 and $450. Until you've mastered the rest, however, we'd recommend you back-burner this stuff.

You might actually want to lay out your artwork in some professional manner, prepare it for the printer, or simply have something that will allow you to make terrific presentations of your own work. These are extremely powerful programs that you will not need until you've mastered the essentials, which is pretty lucky as the two most popular packages—Adobe PageMaker and Quark XPress—run $600 and $700, respectively.

There is a new publishing standard that's been bubbling up over the past several years that has become extremely useful. Called Adobe Acrobat, the program allows you to "print to" this format instead of to an actual printer. The end result is a file in the "PDF" format, and PDF files can be read on just about any computer—Windows, Macintosh, even UNIX. PDF technology is being built into the Mac OS X. Better still, the Acrobat reader is available free of charge; in fact, a great many software publishers include their documentation in PDF format. The software needed to create PDF files is quite inexpensive—about $120.

There is an enormous number of other types of art programs that supplement the stuff you need: font and clip-art organizers, color calibration programs, art-file converters, 3-D imaging packages, and an astonishing number of plug-ins—primarily for PhotoShop, Quark XPress, and PageMaker. Again, you should learn how to use the primary programs first and then decide what enhancements you need. Then, and only then, should you consider adding those second-tier programs. Be warned: Your financial commitment doesn't necessarily end once you buy the software. Every year or two, the software companies issue "updates" to their programs, and seven times out of ten, the updates are extremely worthwhile. They fix bugs, make things easier, extend compatibility with other programs, with the Internet, and even with other operating systems. Quite often these upgrades add important new features. Upgrades usually cost about 25 percent of the original price—the upgrade to PhotoShop 5.0 cost about $150, and was a bargain at that price.

Incremental updates that fix mistakes come out all the time and are usually available for downloading without charge at the software companies' Web sites. Major updates generally go up one full number—say, from version 4.0 to 5.0—and incremental upgrades go up one tenth or one-hundredth of a number—from version 5.0 to 5.1, or maybe 5.01. If you send in your registration form and include your e-mail address, many software outfits will send you notification when an incremental upgrade is posted.

Eventually, you'll probably spend about $2,000 on graphics software, but you can get by for a while starting with Adobe PhotoShop and growing one step at a time.

CONCLUSION

Producing a comic-book story can be quite a challenge but very rewarding as well. What a power trip! Just think, for the cost of a few simple materials you're in charge of the whole production from idea to script to art to distribution. Along with all this comes a certain amount of responsibility. Comics have influenced millions of people over the years, and during the 1950s some people blamed comics for just about all the social problems of the time, especially juvenile delinquency. Since then, the blame seems to have shifted to other things, like drug abuse, films, music videos, popular music, and, oh yeah, easy access to automatic weapons and homemade bombs. By comparison, comics are pretty tame.

Do yourself a big favor and study what some of today's modern masters of comics are producing. Pick up anything drawn by Frank Miller, one of today's greatest living storytellers. Jim Lee and Mark Silvestri can also bowl you over with their scintillating artwork. Check out the efforts of J. Scott Campbell, as well. The list goes on, but these elite few (along with a handful of others) have set a whole new standard for comics over the past few years. Things in comics certainly are a-changing at a rapid pace. We no longer have a bunch of do-gooders flying around in their under-

wear beating up the bad guys. Just compare *Batman* and *Spiderman* from a few years ago to today's *Spawn* by Todd McFarlane or Frank Miller's classic *Sin City*. Quite a leap!

What's next? you ask. That's up to you! Publishers are always asking themselves that very same question. Where are tomorrow's ideas going to come from? Most likely from young people who can relate to their peers, people who understand the preferences, styles, and mindset of others their own age, the comic-book buying public. Sound like anyone you know?

Of course it's not easy. To be the best at anything requires a lot of hard work. Especially when producing a comic book requires you to be not only the producer, director, and set designer of this little play of yours, but also the lighting director, editor, and everything else, including "gofer." You can't expect to do all these jobs simultaneously without lots of coffee.

If you still decide this is what you really want to do (including all these wonderful non-paying jobs) you must be willing to give each phase of every job the time and effort it requires. This is perhaps the toughest part of being a comic-book artist.

Sure, that old bogeyman deadline looms, fatigue sets in, the dog has to go out, and the rent is due, but there are no shortcuts. More bad news is that you get to spend all your nights and weekends at the drawing board. That is, if you're lucky enough to have work. Still interested? Good. You can make a very good living despite all these negatives, and a fortunate few of us (only a few) have skyrocketed to fame and fortune in what seemed to be a heartbeat (we warned you it was just like show business). Yes, it is hard not to be an artist for us, so go ahead and be one. Draw, draw, draw! Frank and I have done our part in our journey through the land of fantasy art with you. Now the rest is up to you.

The next time you see one of us at a comic-book convention, please stop by and say hello. Bring some of your samples; when there's time we'll be happy to give them a look. Always remember: you're in show business, and you will have a lot of competition. Study carefully, work hard, don't get discouraged, and persevere. Only the best will make it, so you must become one of the best. In the words of the immortal Milton Caniff, "We'll see you in the funny papers."

ABOUT THE AUTHORS

FRANK McLAUGHLIN (artist, creator) is a thirty-nine-year veteran of the comic-book industry. During his tenure, Frank has worked with virtually every major comic-book publisher and has served in an editorial capacity for Charlton Comics. Frank has also contributed to many newspaper comic strips and has taught cartooning and visual storytelling at Paier College of Art in Hamden, Connecticut, and other schools.

Frank was also the co-developer of the Writing to Read program, produced for the JHM Corporation through Nova University. Writing To Read employed the use of comic-book storytelling to teach reading and to encourage people to read.

MIKE GOLD (writer, co-creator) is a twenty-four-year veteran of the comic-book industry. Mike has served as cofounder and program director of the Chicago Comicon comic-art convention; director of public relations and, later, group editor and director of development for DC Comics; founder and editorial director of First Comics, Inc.; and editor and publisher of Classics Illustrated. Mike has been operating Arrogant Media since 1993, a company that has packaged comic books for various publishers, including Image Comics and Acclaim.